Christopher Grey's

VINTAGE LIGHTING

The Digital Photographer's Guide to Portrait Lighting Techniques from 1910 to 1970

AMHERST MEDIA, INC. ■ BUFFALO, NY

ABOUT THE COVER

Unless you're stuck in a rut and your gear is in set, unmoving positions, the creation of any photograph, especially a retro image, is somewhat chaotic. You may have a makeup artist and hairstylist on set, and possibly an assistant. In addition, you'll have a plethora of cords, stands, modifiers, and generators to deal with. You'll also have to contend with your client, who may never have thrown herself into such a situation until she saw one of your samples or a shot of a previous client.

The cover photographs I've used on all my lighting books attempt to show that chaos, but also zero in on the important part, the tiny bit of the overall set that, because of your taste and camera angle, will become just one of the images your client will have to choose from. It's just a small part of the overall set, but it's the only part you'll need to make perfect.

Published by:
Amherst Media, Inc.
P.O. Box 586
Buffalo, N.Y. 14226
Fax: 716-874-4508
www.AmherstMedia.com

Publisher: Craig Alesse
Senior Editor/Production Manager: Michelle Perkins
Assistant Editor: Barbara A. Lynch-Johnt
Editorial assistance provided by Chris Gallant, Sally Jarzab, and John S. Loder.

ISBN-13: 978-1-60895-221-2
Library of Congress Control Number: 2011924256
Printed in Korea.
10 9 8 7 6 5 4 3 2 1

Check out Amherst Media's blogs at: http://portrait-photographer.blogspot.com/
http://weddingphotographer-amherstmedia.blogspot.com/

KUDOS

This was an amazing project that involved many extremely talented people.

This was an amazing project that involved many extremely talented people, all coming together to help me create what I think is the best book I've ever written.

When I started in photography I had no idea I would become an educator, much less an author. About ten years ago, and after conversations with other photographers, I became convinced that I knew enough about the craft to educate others. I was happy for that realization, but it's nothing without the cooperation and collaboration of so many others—wonderful people who were willing to work with me for a variety of reasons, to help me reach my goals and theirs.

This book is no exception. There are a large number of people to thank, and I'm grateful to each and every one of them for trusting me and my crew to make them look beautiful beyond what they expected.

To my models, I thank you. You gave me the best performances of your lives, at least to date. I have expectations that all of you will go on to surpass what you did for me. Many thanks to: Gianna Alvarez-Avelli, Denise Armstead, Brianna Chevalier, Amber Colvard, Rozalin Dickson, Annie Fitzgerald, Kai Kaniess, Sarah Jeffrey, Jacqueline Kiefat, Tammy Larsen, Yvonne Ngoy, Gina Nichols, Melissa Osterholdt, Rachel Quaday, Margaret Sinarath, Shane Soulier, Marlee Southam, Aleta Steevens, and Angela Walberg. You were all terrific, and I truly thank you for your effort, participation, and trust.

To Peggy Kouri, proprietress supreme at Melrose Antiques and a tremendous asset for wardrobe and jewelry: thank you for being enthused enough about this project to allow me access to your private collection. Via's Vintage, another terrific store, filled in the gaps with outstanding clothing and deserves kudos as well.

My thanks to Barbara Lynch-Johnt, my editor. After working with me on many books (this is my seventh for Amherst Media), I'm pretty sure she orders another box of red pens every time one of my manuscripts hits her desk. I'm pretty sure she uses them up, too, but I'm grateful for her love of red ink.

I used another author photo from my good buddy, Joey Tichenor (www.jtichenorphotography.com). Joey looks at the world like he's wearing a pair

of novelty store glasses, and his vision is refreshing. Thanks, big guy, but you still owe me lunch for the plug in the last book.

There were two people whose participation in this book was as important as mine. Makeup artist Sandra Avelli researched vintage makeup techniques, brought in the new century's tricks, and made it all work wonderfully and believably. She signed on to this project from the start and was always there to make the vision a reality.

Don LaCourse, a hairstylist working in perhaps the most *haute* salon in Minneapolis, has a passion for retro hairstyles and how to make them happen. He's a genius at what he does, and I was impressed with not only his abilities but his willingness to jump into the project because he thought it would be fun. I can't thank the two of you enough. You've raised the bar for any of us who shoot this work.

To our daughter, Liz. Pictures of you have been in all but one of my books. I wish you were in this one, but you're away at college, beginning your own life. Life on your terms trumps any desire I have to feature you in my projects, as much as I'd like to.

To Sue, my BW. I'll be up in a minute to cook Italian for us, and I have a nice rustica planned. *Poirot* tonight?

ABOUT THE AUTHOR

An amazing and passionate man, Christopher Grey firmly cements his position in photographic history with the publication of this book. His use of light to re-create classic and iconic images is unparalleled, and his succinct, literate, and witty prose unequaled in the realm of instructional publishing. There is, simply, no praise that should not be his.

Skilled, talented, and a commanding presence in any room, he also writes his own biographies.

CONTENTS

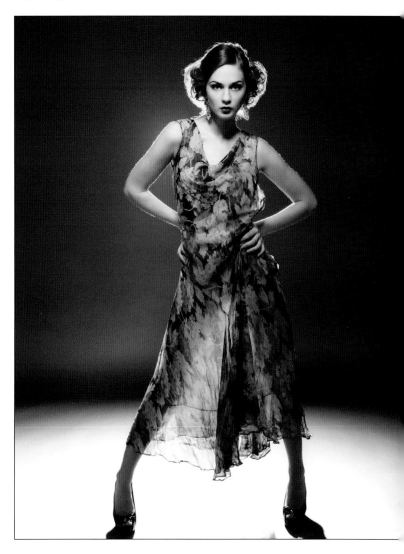

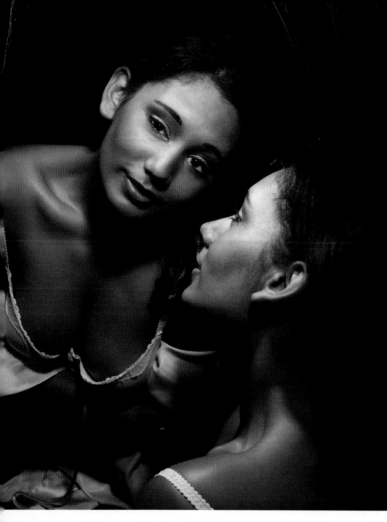

Introduction

While doing a video interview about my work I was asked, "Why are you writing these books?" My response? "I've had the opportunity to shoot almost everything, and I've been paid well for it. At this point in my life, I want to teach others everything I know."

Welcome to an exciting side of photography.

As the popularity of photography as an art form grew, so did the technology that backed it up. In particular, lighting styles changed to reflect advancing technology as well as changing social mores. As fashion and society changed, so did photography.

When portrait photography began, there were few options. Direct sunlight or indirect sunlight pretty much wrapped it up. This was especially true until about 1920. Until that time, the majority of photographers utilized "north light," light that entered the studio through north-facing windows or skylights. It was soft, indirect, and really dim considering the slow ISO speeds of primitive film. Exposures were long, often up to thirty seconds in the Victorian Age. The subjects were required to strike static poses that could be held until the photographer felt the shutter could be closed. Even under such constraints, photographers captured many images that are now considered "classic," even "iconic."

Within the broad spectrum of photographic lighting styles, the lighting created by the masters of Hollywood—George Hurrell, Clarence Sinclair Bull, and others—stand to remind us that there's a lot to be learned from the past.

You may ask yourself, "What will this book do for me?" It's a fair question, and I have the answer: I've run a successful studio for more years than I care to think about, although I've enjoyed them all. In each, I've felt that a mastery of all lighting styles could only benefit my business, because I would be able to photograph people in ways my competition simply could only envy. Over the course of the years, I've tried everything that piqued my interest. Initially, I failed at many of them because I hadn't achieved the amount of control or the depth of knowledge necessary to get the results I wanted.

If there's one thing I've learned that trumps any other lesson, it's that failure and disappointment are wonderful things, for they drive you to figure out why things didn't work out as you thought they would. I will tell you that

> Lighting styles changed to reflect advancing technology as well as changing social mores.

even after all these years as a working pro I sometimes fail in converting my vision to pixels. As a professional, I accept that—even welcome it to a certain degree—but I try to do everything I can to avoid it in the future.

I had two goals in writing this book: to introduce you to many exciting ways to create lighting effects that are largely unused today and to show you how to avoid some mistakes along the way. I'm going to break a few lighting "rules" in this book, but if you know why I do so, your own work can only improve. I will tell you when I do, and why.

Before We Begin

If you want to take my lighting concepts and apply them to subjects and models in contemporary clothing, that's fine. Every technique I outline in this book will work beautifully with contemporary models and clothing. The techniques will add an edge to your work that will put you steps ahead of your competition, exactly where you want to be.

If you're serious about vintage photography, there are a few things you'll have to commit to.

Wardrobe is key to successful vintage photography. You'll need to find a source for vintage clothing that is willing to rent to you. In a larger city, it's not that difficult. In a smaller town, check with the county historical society. Antique stores are another good place to start, because the owner of most any store will know what else is out there and can direct you to the right dealer if they don't have what you're looking for. Rent whenever you can, unless you want to build an inventory of classic costumes. I do both, which means I always have at least a few items that will work for a client. Rental costs are usually 20 to 30 percent of the asking price, per week, and are worth every penny, especially if you gain the trust of someone who gives you access to a personal collection. Some of the items shown in this book, which would have been really hard to come up with on my own, came from Melrose Antiques' store owner, Peggy Kouri (www.MelroseAntiques.com), who gave me access to her personal collection—a kindness for which I'm eternally grateful.

Each decade had its own trends for makeup. These trends were subtle—with eyebrow extensions or lipstick application width being the most prominent and indicative. Find a makeup artist you trust (vintage makeup is different from street makeup and even contemporary photographic makeup) and instruct the artist to learn the art from a given decade. We videotaped my favorite makeup artist, Sandra Avelli, as she applied period makeup to a number of models featured in this book. Videos of her beautiful work will soon be available at www.ChristopherGrey.com/store if you'd like more instruction.

We also taped Don LaCourse as he worked his brand of magic, creating vintage hairstyles that are completely believable. Every single model he worked on was amazed at what he'd done, as was I. Words like "wizard" and "genius" were heard quite often from me. Models used "wow!" as often as "oh my God!" His videos will also soon be available at my store.

Rent whenever you can, unless you want to build an inventory of classic costumes.

1910s—The Edwardian Era

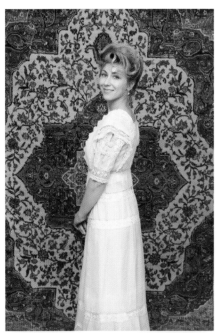

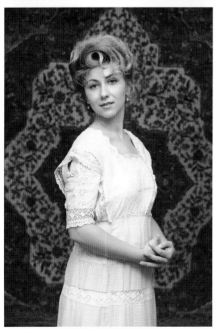

Portrait photography began to come of age around 1910, as did the motion picture industry. The stuffiness of Victorian Age photographs gave way to a more relaxed style, although it's difficult to say it was relaxed in a contemporary sense. Smiles were still unusual and poses were quite prim.

The movies changed from "peep show" Kinetoscopes to multi-reel features (the breakout movie was 1915's *The Birth of a Nation*). Actors in films began to get credit for their work, sparking the birth of movie stars.

Whether you were photographed on a movie set or in a studio, you would have almost certainly been photographed by skylight, window light, sunlight, or a combination of the three. Although powered light was available, film was somewhat insensitive to it, owing to the spectral differences between film (largely blue sensitive) and incandescent light (very little blue in its spectrum).

I wanted to show a few variations of Edwardian imagery and how they might be created and controlled. I also wanted my samples to have a little extra life in them, hence the smiles from my model.

By the way, backgrounds in the early years were either plain walls, carpet, wallpaper, or fabric—anything that might be available. Painted canvas backgrounds were found in the most successful studios.

My first idea was to emulate skylight. I used two medium softboxes and aimed them toward the ceiling, angled slightly to bounce the light toward the model, effectively turning the ceiling into a very large softbox. I used a carpet from the studio floor for the background, clamping it to a long rod and hanging it from a pair of Manfrotto Autopoles.

As early photographers frequently did, I posed my model right next to the background. As you see, she's almost lost within the pattern of the carpet. *Photo 1.1*

The solution was to move the model toward the camera. This change in position brought her closer to the lights, changing the intensity of the light falling on her, which required another meter reading. The move also meant the background would photograph darker and be out of focus. The pattern in the carpet became a frame for her, and the image was much more charming. *Photo 1.2*

Top—Photo 1.1. *Bottom*—Photo 1.2.

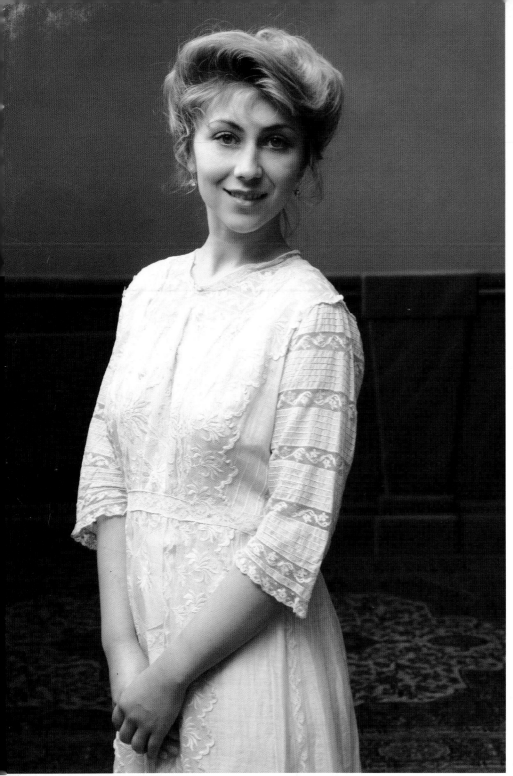

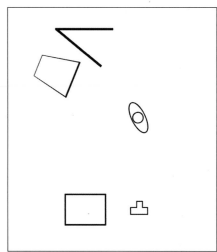

Left—Photo 1.3. *Above*—Diagram 1A.

Early photographers would regulate the skylight with a system of louvers. By doing so they were able to create highlights and shadows.

I removed the camera-right softbox and placed it at camera left, slightly behind the model. This box was powered $+1/3$ over the other to produce a graceful highlight on her side. I used a black bookend to keep light from falling on the background. *Diagram 1A*

Notice how light bounced from the ceiling gently fell on her, creating shadows typical of soft, overhead light. While it is not what one would

consider contemporary, it looks authentic, and that's the key to successful retro photography. *Photo 1.3*

Dark or black backgrounds were often used. I've always liked the drama of black and wanted to replicate an antique photo I have in my personal collection. The image I have appears to have been lit by a large window, with no other apparent light, and the woman's hair tonally merges with the background. It's the only aspect of the shot that I wanted to change, so I opted to add just enough light to get some shadow detail.

I put the two medium softboxes in their original positions, aimed at the ceiling. A third softbox (2x3 feet) was placed at camera left at the height of the model's face.

Once she was metered, and with the dome of the meter aimed at the light, I powered the two softboxes down to $2\frac{2}{3}$ stops below the main. The adjustment proved to be just enough to add very minor detail to the shadows. *Photo 1.4*

Right—Photo 1.4.

I have been asked on more than one occasion to duplicate the look of an ancestor's photo on a living relative. In one instance, a wedding gown had been passed down through several generations, and my client wanted to duplicate a photo she had of her grandmother who was shown wearing the dress. The dress fit her beautifully, and I was able to reproduce the look quite nicely. The lighting was similar to this, as I recall, with a little more contrast. The point is that, by studying the work of others, we prepare ourselves to confidently handle any client opportunity.

For those of you who photograph children, you may wish to buy a few Edwardian or Victorian nightshirts, or replicas of them. It's a great look. Also, the use of such props (available through antique stores as well as some contemporary prop houses such as www.elenacollectionusa.com) may prove to be a great value to your studio, as it will likely be something that your competition does not offer. If you're the only photographer to offer it, it's worth it to spend a few bucks for props. *Photo 1.5*

Above—Photo 1.5.

1920s—The Roaring Twenties

Most studios were located in little rooms on the top floors of commercial buildings.

The transition from north light and minimal electric light to more brightly, artificially lit studios hit its stride at the start of the '20s. Photographers learned to adapt the hard, hot lights that were available for stage productions to softer light that was more complimentary to the everyday clients who graced their studios. They likely learned quickly that ambient light from existing windows or skylights could be mixed with generated light to soften shadows and augment the look of their portraits.

One thing they frequently overlooked was shadow retention, as evidenced in the many images from that era (including many in expensively produced magazines) that show a model or subject placed against a wall and throwing a shadow. This was most likely the result of working in small spaces, as most studios were located in little rooms on the top floors of commercial buildings. Many photographers worked out of their homes, which meant that, from Monday through Friday, there would be no dining in the dining room.

In a way, it doesn't matter. What we end up with is one more "tell," a little detail that gives something away, in this case an age reference. As you'll see in later chapters, this technique was worked with and built upon for effect, especially in classic Hollywood and fashion lighting. Understanding how and what our predecessors did is essential if we are to produce images that look as though they are from an earlier age.

One for Main, One for Fill

As photographers began using hot lights over skylights, a certain scenario began to emerge, with photographers using two lights to illuminate the subject's face. A main light would be placed to the left or right of the camera, and the second source was typically placed on the opposite side at equal distance and height, but powered lower than the main, probably by just using a lower-wattage lamp.

This style shows up in every decade before the 1960s. I'm sure you'll read more of my comments on it in later chapters, but the simple truth is, I hate it with the white-hot intensity of a thousand suns. The second light, dimmer though it might be, still throws its own shadow and, while it does provide fill, the extra angle away from the camera guarantees the shadows will not be

evenly filled. This is especially true of shadows under the nose or next to the eyes.

If you're going to use a two-light scenario, there's really only one place to put the extra light where it will do the least damage, and that's directly over the lens' axis and as close to the lens as possible. You'll run the least risk of not filling every shadow when the fill light is in this position.

For the first example using just these two lights, I placed the model about 5 feet in front of a white paper background. My camera (with the fill light directly over the lens) and my main light, a strobe in a beauty bowl with a 25 degree grid, were 5 feet from the model. Both were metered separately. I wanted the fill to be one stop under the main and, when that was achieved, both lights were fired at the same time to get a working aperture. Note that the grid on the beauty bowl kept its light off the background, which was lit only by the fill light. At that distance, the background receives $\frac{1}{4}$ the light that hits the model, already one stop less than the main, rendering it a light gray. *Photo 2.1 and Diagram 2A*

Left—Photo 2.1. *Above*—Diagram 2A.

Right—Photo 2.2.

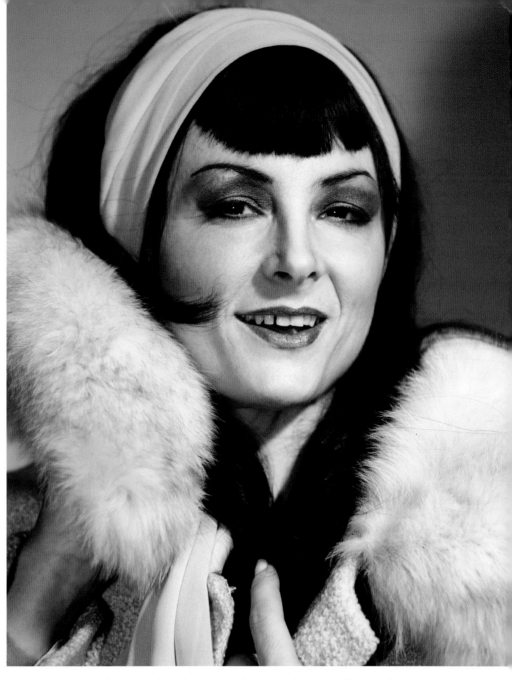

If those early photographers had enough room, they would use subject-to-background distance to control the brightness of the background.

I moved my model and my lights an additional 5 feet from the background. This would give me a darker background because the light hitting it would be substantially lower in power. I made a change to the fill light, just to give the shot a more authentic flavor, by moving it under and slightly to the left of the lens. If you look carefully at the final shot, you'll see that the main light angles down on the model's face but the shadow on the background angles up. It's an interesting trick because even a lighting-savvy viewer might be unsure about how it was accomplished. *Photo 2.2*

You may want to retouch the extra catchlights in the model's eyes, mostly because they'll be almost dead center, an unattractive place to be. I left them in place, but you'll only be able to see them if my editor reproduces the

image in a sufficient size. Note also the short depth of field. These images would have been made with a view camera and shot under relatively dim light given the slow ISO of film being used at that time. Believe me when I say the photographer would opt for faster exposure time versus more depth of field.

Soft and Open Shadows

My first set of images featuring this model was designed to show a typical mix of soft, generated light and ambient studio light. I planned to show a bit of a shadow but wanted that shadow to be open and soft, not too deep. The same held true for any shadows on her face or from her body position. I also wanted to place her against a wall as a background, because that's what many photographers did back then.

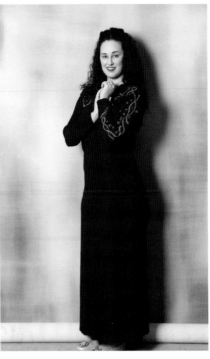

I began by rolling a canvas background up from the floor, using push pins to secure it to a wall. I wanted it as flat as possible. After it was in place I spent a few more seconds snugging it up to the wall, to eliminate any stray bulges.

My main light would be a medium, 3x4-foot softbox but, by itself, would produce light that would be too contrasty for the look I wanted to achieve. You can see how deep it is in this full-length test photo. *Photo 2.3*

I turned off the softbox and set two lights, with parabolic reflectors, well behind my camera position. The stands were extended up to about 8 feet, with the parabolics aimed mostly at the ceiling but angled slightly toward the model. Each light was metered independently of the other, and to the same power. I had already metered the main light so I knew to power each of the two parabolics −2 stops under the power of the main. As you can see, there is no shadow of any consequence. *Photo 2.4, Diagram 2B*

The softbox was turned back on and I re-metered my model one final time. Even though both parabolics were 2 stops less than the main, the additional light added +$\frac{1}{3}$ stop to the overall exposure.

About midway into the shoot, I asked my model to give me a bit of attitude and confidence. Notice how she's holding her hand. Slightly "breaking" the wrist in such a way gives the image a hint of aristocracy. Note also how the shadow is smooth and open but still contours the model. One final note: if you know you absolutely will not use any of these in color, a custom white balance is not necessary, but you should do it anyway, just in case. *Photo 2.5*

Top left—Photo 2.3. *Top right*—Photo 2.4.
Bottom—Diagram 2B.
Facing page—Photo 2.5.

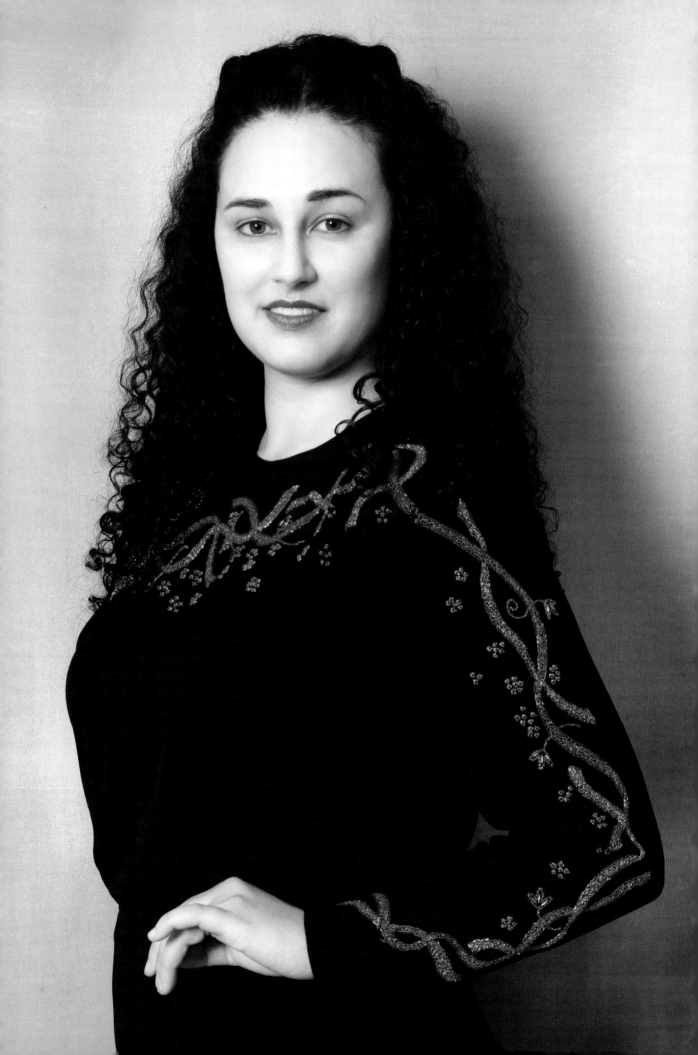

BACKGROUNDS WITH AN EDGE

In the late 1910s and through the '20s, photographers frequently used rather garish wallpaper patterns as backgrounds. This was probably quite trendy, reflecting the emerging enthusiasm of the decade along with new freedoms being demanded and achieved by women.

We did a wardrobe check shortly after the model and wardrobe stylist arrived. I noticed a rather elegant green dress on the rack and remembered a piece of upholstery fabric I'd purchased some years ago. It had some of the same color green in it, was "garish with class," and would be perfect for this shot. I knew the tones would match when converted to black & white. The same would hold true for the colors in her hat.

Hats can pose problems for photographers because it's tough to get enough light under some brims to clearly see the subject's face without having to aim the light up into the face. What's most difficult is to retain an attractive nose shadow.

I also felt it would be best to direct as much attention to her face and hat as possible, as the background would be more distracting if the image was evenly lit. This way of thinking is contemporary, not what early photographers would do, or even could do, as a matter of course, but a little artistic license would only enhance this concept, and mine had recently been renewed.

I used one medium softbox for the light, setting it very close to my subject, and angling it steeply toward the ceiling. The bottom of the box was less than 3 feet from the model and just slightly higher than the top of her hat. I could easily see where the light fell off, and I used that line to create a vignette that began at her bust, darkening as it went down. *Photo 2.6*

The hat was a fun prop, in amazing condition after all these years. I wanted her expression to reflect the spirit of the prop and the background. *Photo 2.7*

SKYLIGHT DRAMA

Many photographers were still using their skylights for illumination. For the last shot with this model, I wanted to create a moody and soft image that reflected that look. The stylist had brought a vintage black velvet coat and feathered hat, wonderful props and perfect for such a shot.

I hung my medium softbox on a boom and set it about 3 feet over the model. She was positioned so that roughly ¾ of the softbox was in front of her. The box was angled slightly down toward her. *Photo 2.8*

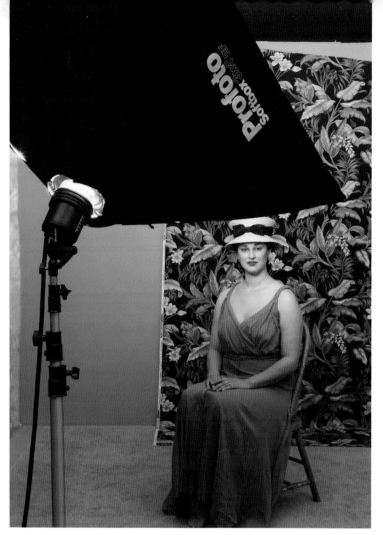

Above—Photo 2.6.
Facing page—Photo 2.7.

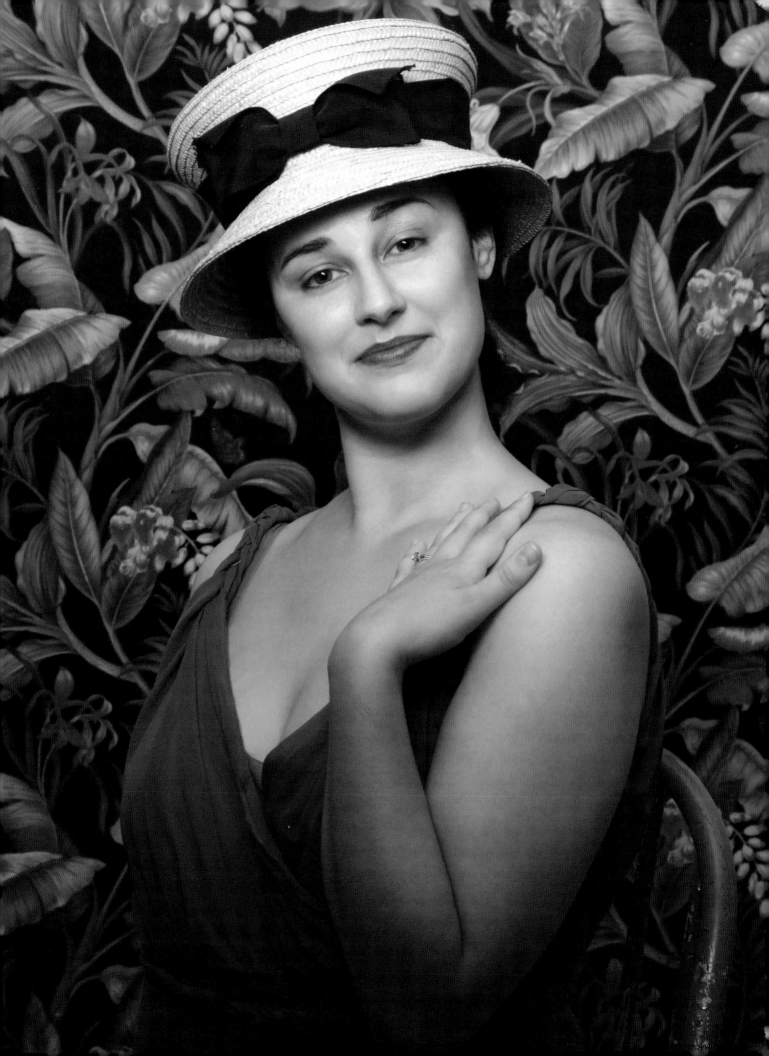

The toughest part of this shot was figuring out the correct light-to-background distance. I wanted the background to be dark enough to add drama, just not so dark as to create tonal merger. The model and light were moved away from the background until the correctly metered light on her was 2 stops brighter than what fell on the background.

I very much favor eye contact between the viewer and the subject, but that's part of my style and not necessarily that of earlier photographers. I asked the model to turn her head away from me and tilt it slightly up toward the light. I also asked her to look at a corner of the studio and slightly downward. The result is an evocative and dramatic image that would make any retro photographer proud. It certainly did the job for me. *Photo 2.9*

Above—Photo 2.8. *Left*—Photo 2.9.

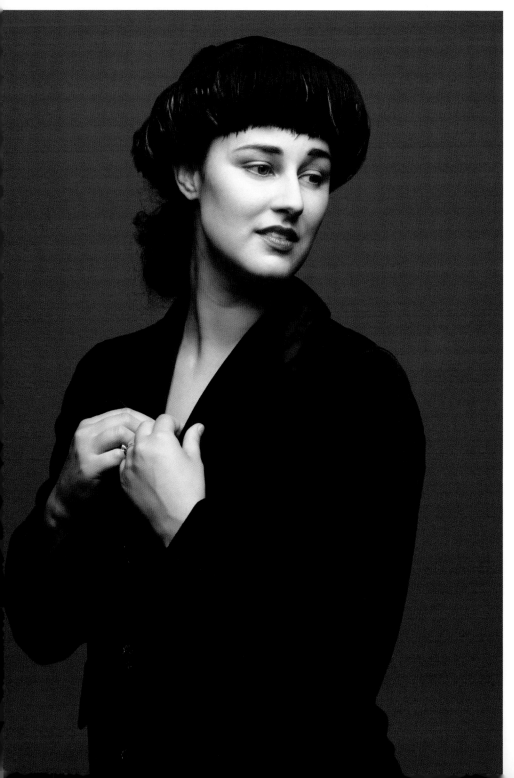

Left—Diagram 2C. *Right*—Photo 2.10.

OH BOA

Inspired by a George Hurrell shot of Mae West, I wanted to build on it slightly by eliminating some spill from the main light onto the background. It was probably originally caused by placing the main light farther from the subject than I would place mine, which would be about 5 feet from the model. I chose that distance to get a combination soft/hard shadow that would beautifully illuminate and contour both her cheeks. I suspect Hurrell's light was a de-focused spotlight with a Fresnel lens, smaller in circumference than the beauty bowl I was using, but set farther away from Ms. West. That extra expanse would account for the visible spill on his background, as the light would have had more distance over which to lose strength. I also suspect that the distance Hurrell chose had more to do with heat generated by his light and its proximity to the client than anything else.

I used a basic parabolic, fitted with a 20 degree grid, to add highlight to the back of the model and the feather boas she was wearing. This light was powered to +$\frac{1}{3}$ stop over the main. ***Diagram 2C***

As I'm writing this, I can only hope that the reproduction in this book faithfully mimics the detail I'm looking at as I tap the keys, because publication reproduction is always compressed compared to what we see on our

screens. There is only the slightest tonal merger in the deepest shadows on the left side of her head, nearest her right eye and cheek. This is totally acceptable for the era and does not require an additional kicker to eliminate it (although that is certainly an option for you). Should you choose to add an additional light, my suggestion would be to keep it very dim, at perhaps $-\frac{2}{3}$ stop, or just enough to be felt but not really seen. *Photo 2.10*

The use of dramatic lighting increased along with the quality of electric lighting, especially at the Hollywood studios, where the photographers seemed to be having a great time playing with all the new toys.

My last samples from the '20s deal with the drama typical of the era and a trend that outlasted the age of film.

I began by setting a medium softbox in front of where my model would be looking, the profile position. I intended to slightly underexpose the main light as well as the hair light, a strobe and parabolic with a 20 degree grid. Once they were metered to the same power I made a mental note of the f/stop and would set my camera's aperture $\frac{1}{3}$ stop less than that reading.

Top—Photo 2.11. *Bottom*—Photo 2.12.

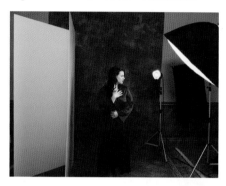

Before my model put on her vintage wardrobe I asked her to come on the set so I could correctly position another strobe and 20 degree grid just far enough out of the frame so it wouldn't be seen. Putting it so close means the light will just rim the model's contours while throwing interesting shadows from her hair and, to a lesser degree, her hands. To keep light off the lens, I hung a piece of black foamcore from another stand, butting it up almost to the edge of the frame.

A white bookend was placed behind her to keep detail in the side of her hair and the black dress she'd be wearing. This bookend also hid the light behind it, a plus for me because, aimed as it was, it would have to be flagged off anyway. *Photo 2.11*

The rim light was powered up $1\frac{1}{3}$ stop over the main, giving it the full stop of overexposure that I wanted. Note the teardrop of light when she turned just a bit away from full profile. The result is a shot reminiscent of a Hollywood studio publicity still—perhaps one created to promote a certain movie. *Photo 2.12*

There are no dummies in a publicity department. As soon as society allowed it, the studios began to get racier with their shots, often wrapping a star or, usually, a starlet, in

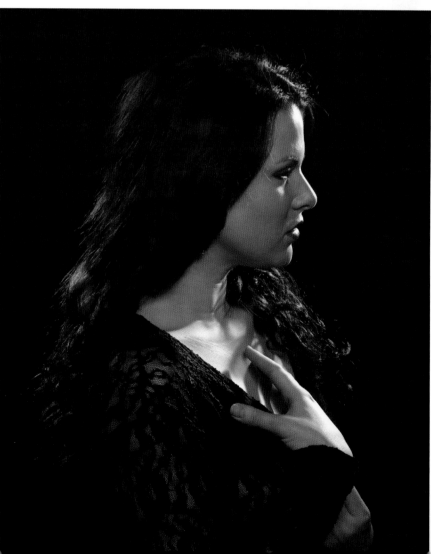

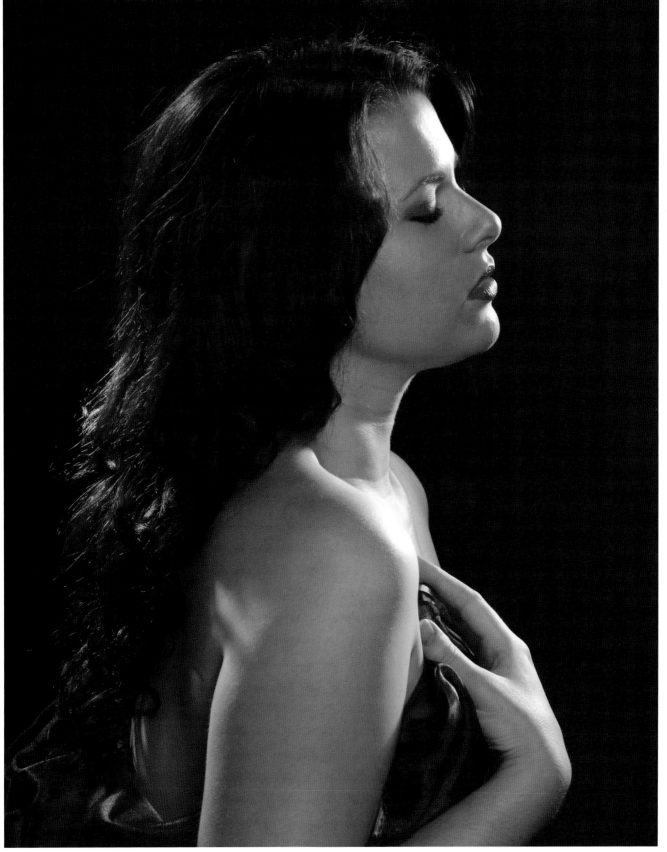

Above—Photo 2.13.　loose cloth. Add a little sexual tension, like her closed eyes, and you've got a shot that was hot in the '20s and is still in use today. If I had a dollar for every frame I've taken in this manner, I'd be much closer to reaching my goal of buying a private island in a chain not serviced by a major airline. *Photo 2.13*

Next up, I wanted to emulate the effect of short focus and large format. Any photographer worth his or her salt back then shot portraits with a view camera and 8x10 or 11x14 negative film. When coupled with short focus (a wide-open aperture) and a long focal length lens, the photographer was able to direct attention exactly where it was wanted, usually to the subject's eyes.

While today's telephoto lenses will allow for short focus, the effect doesn't look the same because early photographers were able to adjust the individual planes of the lens board and film carrier (the front and rear "standards") to increase the short focus effect. It was just another creative control, but savvy shooters exploited it whenever possible.

As I mention elsewhere, subjects were frequently posed very close to the background. Indeed, wall shadows were a Hollywood staple for years. Far be it from me to rock the boat and shoot something "correctly."

I placed my model a mere 18 inches from the wall, lighting her with a single strobe and umbrella. No additional fill was used, as I wanted the dark shadow to contour her face, in keeping with the lighting style of the day. You can see that the point of focus is on her eyes but that everything else is still too sharp. *Photo 2.14*

In Photoshop I created a duplicate layer and employed a Gaussian Blur of 48 pixels. The image was masked and painted through to reveal only what I wanted to stay sharp. It's a matter of taste, but I used various percentages of opacity as I brushed through the mask as I moved away from her face.

After the first mask was complete, I duplicated the original layer again, adding a Gaussian Blur of about 6 pixels. This layer was also masked and painted through at 100% for just the sharpest image details, her eyes and lips. Her nose was painted through at 30%. *Photo 2.15*

After the image was converted to black & white, the true look of this technique became very apparent—and very successful. A final touch was to add a sepia tone to the image. I used Photoshop's Variations, adding one hit each of yellow and red at the Fine setting. I also cropped it to 8x10 proportions, in keeping with the style of the day, and added a touch of grain. See chapter 7 for another way to accomplish this look. *Photo 2.16*

> Early photographers were able to adjust the individual planes of the lens board and film carrier.

 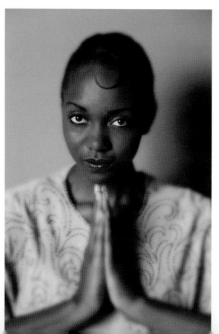

Left—Photo 2.14. *Right*—Photo 2.15.
Facing page—Photo 2.16.

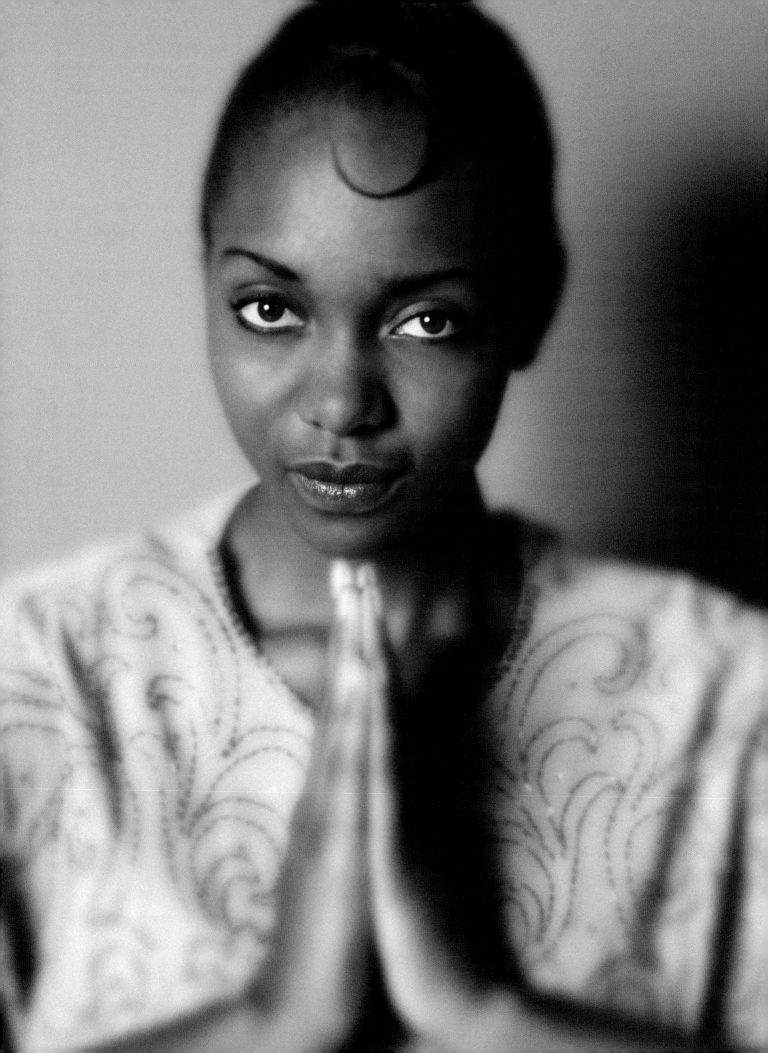

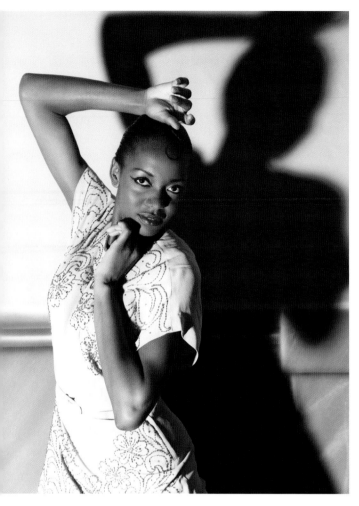 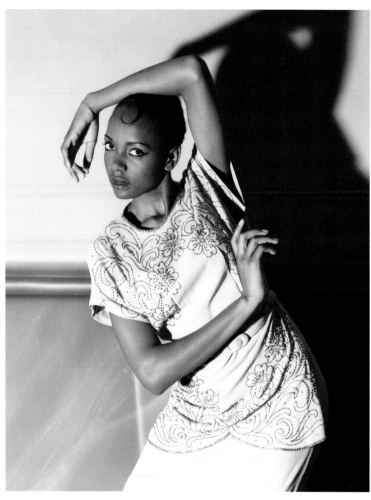

Left—Photo 2.17. *Right*—Photo 2.18.

UPWARD SHADOWS

Early shooters used upwardly directed shadows to enhance the feeling of entertainment, creating what (at least to my mind) resembles shadows cast by footlights in early performance theaters.

This next image was inspired by photographs I once saw of Josephine Baker, the first African American to break the performance color barrier with integrated shows. By all accounts, she was a remarkable woman; a singer, dancer, and actress whose career spanned decades.

This is a one-light setup—a strobe with a basic parabolic reflector set on the studio floor on a shortie, a 12-inch stand. My model was directed to act like a stage performer and to give me attitude. She did a terrific job, and the edits from this set are all great.

One of the problems you'll need to deal with if you use this scenario is the nose shadow itself. It does angle up, and that's usually a bad thing. If you are mindful of your model's angle to the light, you can minimize the number of "bad" images this light may produce by directing her to aim her head at the light. On the other hand, early photographers rarely gave a rat's backside over where the shadows fell. It's your call. If you see something happening that's over the top, well, shoot. Worry about shadows later. *Photos 2.17 and 2.18*

CROSS LIGHTING

My final series with this model deals with cross lighting, two lights set at equal distances from the model, slightly ahead of her body, and powered to the same f/stop where the subject will be standing. Now, there are compositional hazards here because if the model turns her head straight to the camera, the duplicitous shadows will be terribly unflattering. This quick shot will show you exactly why, but the quick explanation is that there is zero light falling into either eye socket. Bad news for beauty. *Photo 2.19, Diagram 2D*

However, as soon as she turns her head in either direction, the celebrity look of this scenario is immediately noticeable. Because cross lighting is not a "tried and true" arrangement, its drama will get the viewer's attention.

Before we began the shoot, I had a conversation with the model regarding the attitude I wished to present. I think such conversations are crucial to the success of images such as these, as you must understand each other completely before you knock off a single frame. I told her that I wanted attitude and that I wanted her to believe she was, indeed, a movie and theater star. This may seem rudimentary, but I find it necessary whether I'm dealing with an experienced model or someone off the street. It's not only important to put your model on the same page as you but, given that most of the people who hire you will be rank amateurs, it's imperative that you set the tone for the shoot. A successful shoot is not up to the model, the makeup artist, hairdresser, or wardrobe stylist, it's totally on you to pull it all together. *Photo 2.20*

Top left—Photo 2.19. *Bottom left*—Diagram 2D. *Right*—Photo 2.20.

1930s—The Dirty Thirties

The often-used title for that decade had nothing to do with sexual mores but rather with the incredible dust storms that ravaged the nation's food belt. The Great Depression was in full swing at the start of the decade, with many citizens impoverished or, at the very least, in need of fresh food and clean water.

Photographically, lighting styles were evolving into the greatest burst of visual elegance to date. Movies had become the "great escape" for people, and audiences in the '30s saw movie stars as even *more* "larger than life" than they did in the '20s. MGM's tag line, "More stars than there are in heaven" was never more valid, as actors became the elite royalty of the country.

Personally, I think the two great photographers that fully emerged during this decade, Clarence Sinclair Bull and George Hurrell, were geniuses at what they did, but I don't think they truly understood their craft. After studying their work for years (I happily own several original and signed Hurrell prints), I'd have to say they understood the nuances of photography, especially lighting, but on only an intermediate level. They frequently made "mistakes" that would doom us if we used them today on, say, a high school graduate. Upwardly directed shadows, sometimes multiple shadows, could brand any one of us as a low-grade photo moron unworthy to wield any camera of more than two megapixels. Unless we're shooting retro Hollywood, of course.

Hurrell and Bull were hired to photograph both the biggest and smallest names in Hollywood. Regardless, the people they shot had attitude. For historians to say that their results were timeless because the photographers were able to draw some monumental performance out of an actor, to look deeply into their souls, I say *phooey*. The stars could act; that was their job, after all. They only required a little direction and trust in the photographer to make things happen. Your clients will need more direction from you to acquire the attitude of a star and make the shoot successful.

Uncomfortable Posture

Posture is paramount (no pun intended) for a great retro portrait. I've found it useful, sometimes, to place the subject in a somewhat uncomfortable position. It forces a concentration to the camera because of the position, and that

Photographically, lighting styles were evolving into the greatest burst of visual elegance to date.

One of the problems you will encounter with upwardly directed light is that the upper lip area will shadow.

will produce an image with much more power than if the model was just sitting on a stool or leaning against a wall.

I wanted to break a serious "rule" with the first shot, that of upwardly directed light. I've seen many images from the '30s and '40s that use this approach and, while I think it's a little goofy by today's standards, it is authentic and will work nicely with vintage clothing.

I began by push-pinning a pillow to the wall, lower than where the model's head would be, then placing a piece of faux fur over that. I'll tell you that I was a little disappointed in the "fur" because it looked great on the bolt but more like a fleece blanket after rinsing the bolt-folds out of it. *Note to self:* buy a small piece to wash and evaluate before buying the full, expensive, chunk.

My thought here was that the model would need to squat slightly, to get her head in the right place on the pillow. I knew this would put some tension in her body that would be difficult for the viewer to make sense of. I was engineering an attitude that I would amplify by using verbal direction during the shoot.

My main light was a basic parabolic reflector, set low to the floor and aimed up at the model. I placed a hair light, a beauty bowl with a 25 degree grid, on a boom from overhead. I didn't want to overpower the shadow from the main light, I just wanted to add a little visual interest, so the hair light was powered one stop under the main. Additional fill for the shadows was provided by a white bookend at camera right.

The result of the strange posture and upwardly directed light is totally reminiscent of the early '30s. *Photo 3.1*

You'll read this many times in this text: retouching was extremely important to the success of any image, and every part of a chosen negative was worked over. One of the problems you will encounter with upwardly directed light is that the upper lip area will shadow. You should fix this, if you can, as it will add to the illusion of perfection. *Photo 3.2*

Left—Photo 3.1.
Right—Photo 3.2.

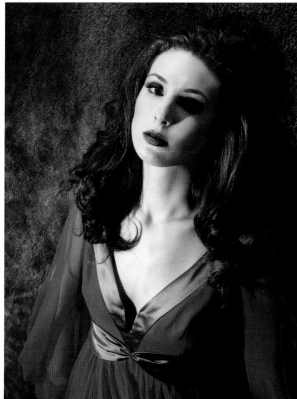

I decided to contemporize this shot a bit by raising the power of the hair light to $-\frac{1}{3}$ stop below the main. I asked the model to tilt her head down, creating a more traditional nose shadow. It's still a little broad, and not quite in the right position for traditional portraiture, but the lighting arrangement and pose together create a great retro look. The model's attitude, both passive and aggressive, doesn't hurt, either. *Photo 3.3*

Deep Shadow and Tonal Merger

Another favorite Hollywood lighting approach was to use deep shadow to create contour and mystery. Tonal merger, where the tones of the shadows or highlights merge with the shadows or highlights of the background, was largely ignored in favor of the shape of the face and composition of the image.

The next shot is a two-light image. My main light was a basic parabolic on a boom, set directly over the model and aimed straight down. I'd moved the boom until she was lit only by the edge of the light, essentially wasting most of it. You can also see that the light on her sleeve is brighter than that on her face. It didn't matter, though; the light was now gorgeous, ending just behind her forehead.

To add fill, I set a second light, also fitted with a basic parabolic, directly over the axis of the lens. This would add a catchlight to her eyes and give them some life. The fill light was powered at two stops under the main light, but I've seen classic images that look like they've been shot under wider ratios, perhaps three or four stops under. It's your call as to what you think looks good because it will vary based on the shape of the subject's face and the depth of the eye sockets. Play with the lighting and check the results on your computer before going for the final shot. As always, meter each light separately to get the correct ratio, then together to get the working aperture. *Photo 3.4*

Mixing Under- and Overexposure

An interesting lighting trend emerged in the '30s: the pictures looked as though they were underexposed, yet perfectly exposed, with neither being completely true. It was a cool trick because the main light, a soft and flat light source, resulted in the underexposed (by roughly a full stop) look,

Below—Photo 3.3.
Facing page—Photo 3.4.

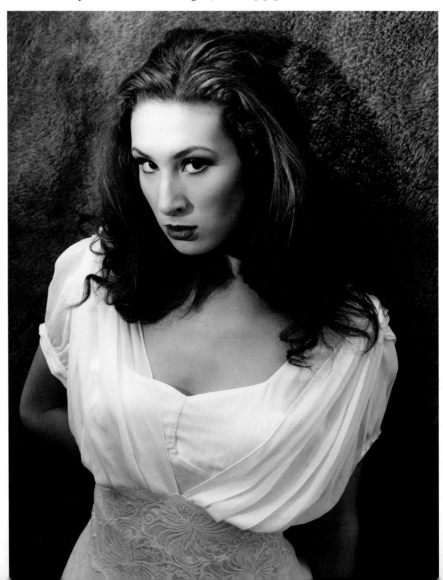

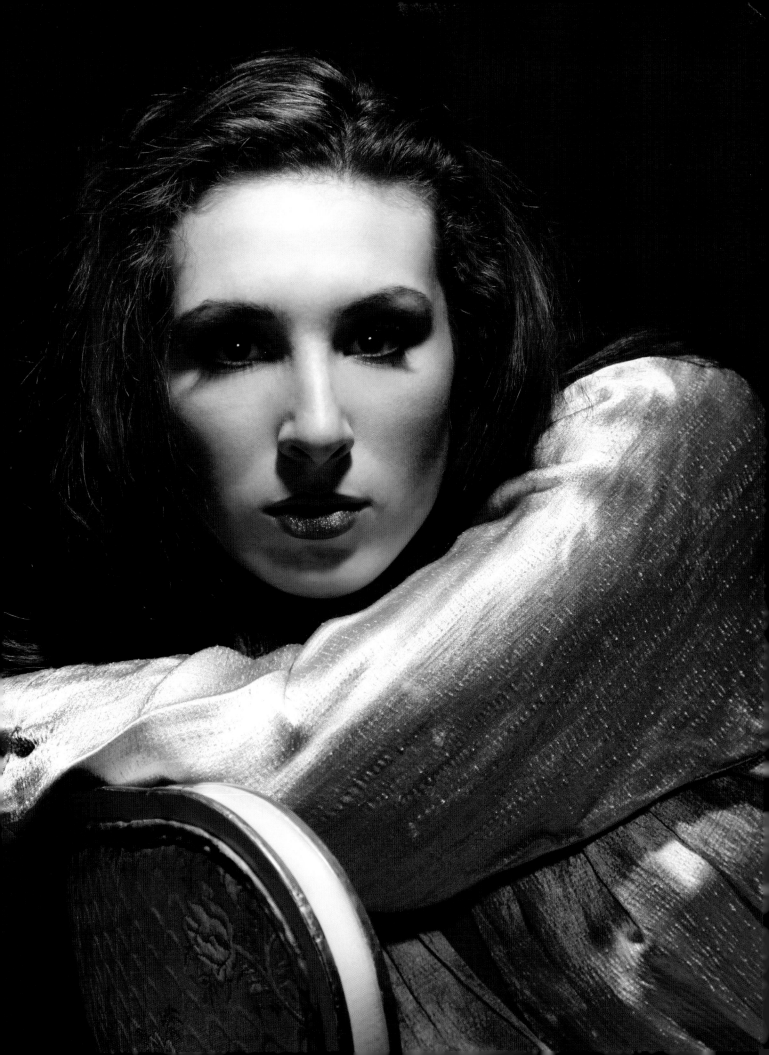

but the accent light produced a hard, contrasty lighting effect. It was also a beautiful technique because it did everything it was supposed to do, imparting a certain sense of mystery that a viewer could not immediately figure out. This technique, this mix of contrasts, was also a departure from most other portrait scenarios, whether lit with an overall soft or hard light.

I began with a beauty bowl covered with an additional, sheer-cloth diffuser (called a "sock"), set just above the camera. My meter gave me the correct f/stop, and I set the camera's aperture to one stop less. I moved a parabolic with a 20 degree grid, mounted on a boom arm, directly over the model.

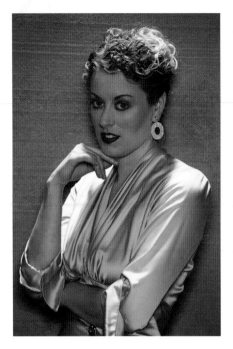

Left—Photo 3.5. *Right*—Photo 3.6. *Facing page*—Photo 3.7.

So here's the part that might be a little hard to wrap your head around: Because I was deliberately underexposing the image while looking for bright accents, I had to power the kicker light much brighter than you'd expect, $1^2/_3$ stops over the working aperture, not over the main. If I had simply bumped the hair light up $^2/_3$ stop, I would not have totally overcome the one stop of underexposure I'd built into the shot. In other words, the highlight would still be darker than "normal." The extra stop overrode the camera's aperture adjustment, while the additional $^2/_3$-stop guaranteed the extra overexposure I wanted. In color, the flaw of deliberate underexposure is obvious, and colors, especially flesh tones, look a bit muddy. *Photo 3.5*

After the image was converted to black & white I created a second layer in Photoshop. The layer was lightened, a mask was created, and the model's eyes were brightened by selectively removing the mask.

Any Hollywood shot is intended to be larger than life. Lightening the eyes, even slightly, contributes immensely to achieving that end. Working in their darkrooms, photographers would have done this as a matter of course, especially with images like this. With Photoshop (or other image manipulation software), it's so much easier. *Photo 3.6*

You can easily ramp this effect up by simply increasing the power of the hair light by $^1/_3$ stop. The effect is dramatic and beautiful, but you'll want to keep as much spill as possible off the background, keeping the basic tones intact. For photos like this, extra overexposure is a real plus; it will make your retro portraits much more believable. *Photo 3.7*

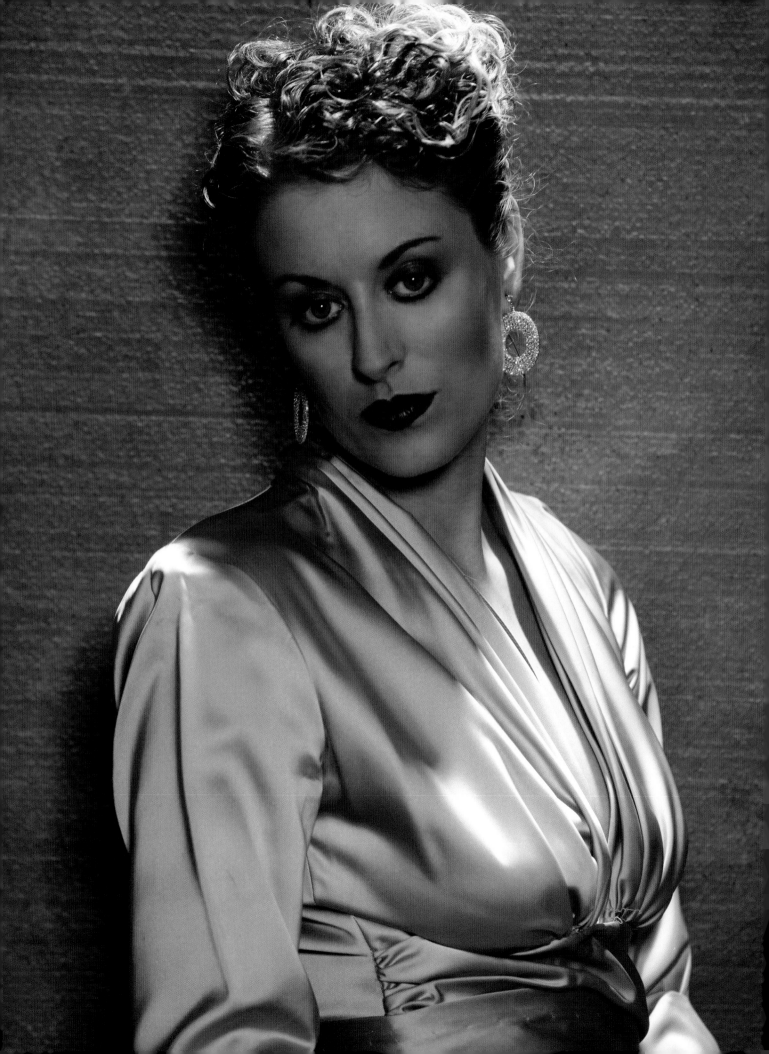

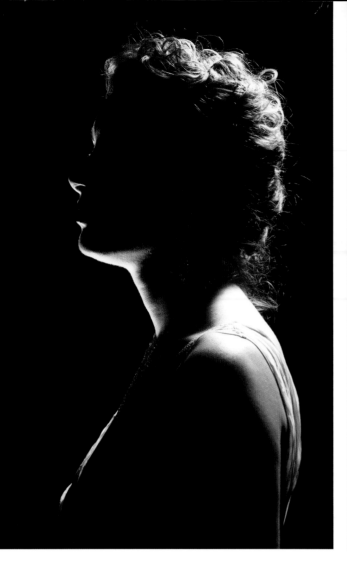

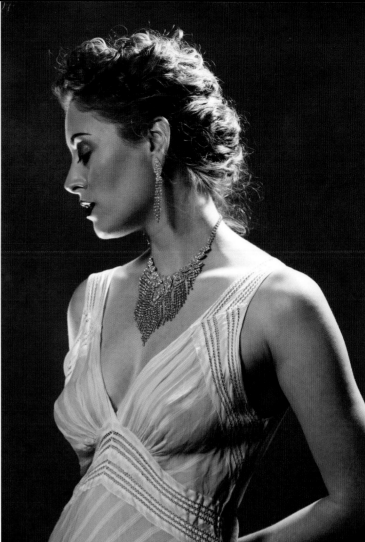

I took this a step further and added another light, directed from below the subject. *Photo 3.8*

I put a second light, in a parabolic and fitted with a 20 degree grid, on a 12-inch stand (the "shortie" I mentioned earlier). Even on the shortie, the edge of the parabolic was almost 18 inches off the floor. If you want more control over the spread of the light, you may want to build a stage for the model to stand upon. This means, of course, that you will have to get your camera and main lights correspondingly higher to leave room for the accent lights. It's a good idea to be sure the stage is stable, too. Liability insurance is a great idea, just in case. *Diagram 3A*

The main to accent light ratio was the same as in the earlier sample. Taking the time to completely control where the accent lights were hitting allowed for the creation of an evocative, beautiful image, totally reminiscent of the 1930s. Your clients will love this trick, but be sure your subject has a facial structure that will be attractively represented with this scenario. Large noses, deep-set eyes, or sallow cheeks may require a different approach. *Photo 3.9*

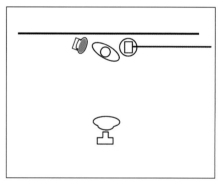

Left—Photo 3.8. *Right*—Photo 3.9. *Above*—Diagram 3A.

BLOWN-OUT HIGHLIGHTS

Two classic looks were achieved with three lights with grids, precise positioning of the main light to establish the contrast and specularity of the light, and serious overexposure from the kickers.

Two lights were set about 6 feet behind the model, each sporting a 40 degree grid, quite wide for many applications but perfect here because the lights will cover all of the body I wish to include in the images. I began by measuring each light separately and to the same power, f/16 as I recall, although that doesn't matter as much as the final main to accent light ratio. I wanted these accent lights to be really bright, to actually burn out any detail that would be directly hit.

Because the lights were covered with rather wide grids, the risk of flare onto the lens was guaranteed. To remedy this, I moved black bookends into the scene, keeping light on my beautiful model while keeping it off my beautiful lens and saving my glass.

The main light was fitted with a 10 degree grid and placed on a boom so it was directly over the model, in a straight line to the axis of the lens, and about 4 feet from the model. This light was powered 1 stop below the two kickers, but this reading would be the working aperture for the camera. One note of caution here: you should not meter the light in the traditional sense, with the meter below the chin and aimed at the camera. The correct way to meter any light fitted with a grid is to meter with the dome placed between the model's eyes, aimed at the camera. *Diagram 3B*

Let me back up just a bit. When the light is placed in this position, directly over the lens' axis, and the subject is looking directly at the camera, we get butterfly lighting, but when the subject moves her head to either side, the effect is more like broad or short lighting. This means that a light placed this way, along the axis, is extremely versatile, perhaps even more so than with actually using a set light scenario. It all depends on how you visualize the placement of your model's face in your composition.

My first series was very successful, absolutely duplicating a classic look of the '30s. My model sat on a stool (which was cropped out when I went to 8x10), toying suggestively with her robe. Again, this is a classic look, as the female stars of the time were quite aware they were being exploited for their acting ability as well as their sex appeal. Note the splash of light on the model's nose. This is often considered a "mistake" in traditional portrait photography, and it certainly can be. The trick is to keep it as minimal as possible. Too much light will make the nose look too prominent. A nose splash from both sides is visual death, as the nose will look huge. It's important to control it completely, and the easiest way to mess it up is to place the two kickers too far away from the model's sides. If that's what you see, move the lights in and flag them more tightly. You can thank me later. *Photo 3.10*

My second setup was really easy. All I had to do was move the boom-mounted light within a couple feet of the model and power it down to the

Top—Diagram 3B. *Bottom*—Photo 3.10.

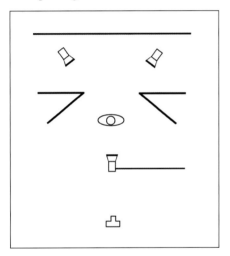

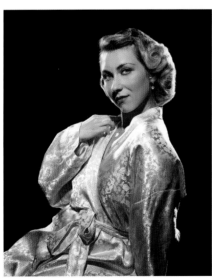

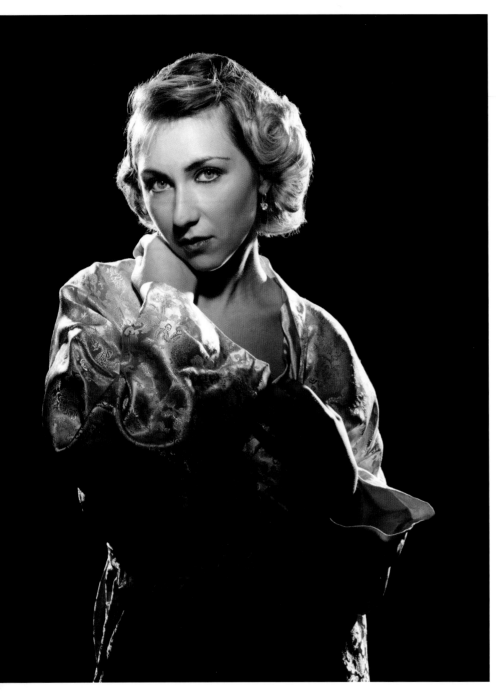

previously determined f/stop. There is no set formula to determine the distance, as it all depends on how much of the model's face and figure you want to show. Remember that the kickers will define the rest of her shape.

My model was standing this time, with the circle of light much more clearly defined. I think you can readily see how cool and dramatic a grid-spotted main light can be. *Photo 3.11*

Parabolic reflectors with grid spots will produce beautifully contrasty, modeled light. Is this appropriate for a head and shoulders portrait? When dealing with retro light, absolutely. Even though this shot was cropped above the transition zone, the part of an image that recedes into shadow, the result

is fantastic. Add a little sepia toning and crop to a traditional size, such as 8x10 inches, and you'll have a product that your client's friends will look at and say, "Is that your grandmother? You look just like her!" Your client will then tell her friends about the incredible photographer she hired to get the image (unless she's protective and selfish, of course, in which case you'd better have an advertising program in place). *Photo 3.12*

One further note: in the 1930s, '40s, and '50s, Hollywood's retouchers spent hours slaving over negatives to make everything perfect, working on the eyes and blemishes but spending the most time getting rid of flyaway hair. I typically do the same thing when I feel it's necessary, especially on retro hair, because it's worked and pinned, essentially beaten into submission to get the correct style. I clone out most of it, leaving a few stray ends just to keep it looking natural but still perfectly styled. The worst image you could produce would be one with every hair perfectly in place. It doesn't ever work that way in real life, even with someone who is as follicly challenged as your humble author.

Right—Photo 3.12.

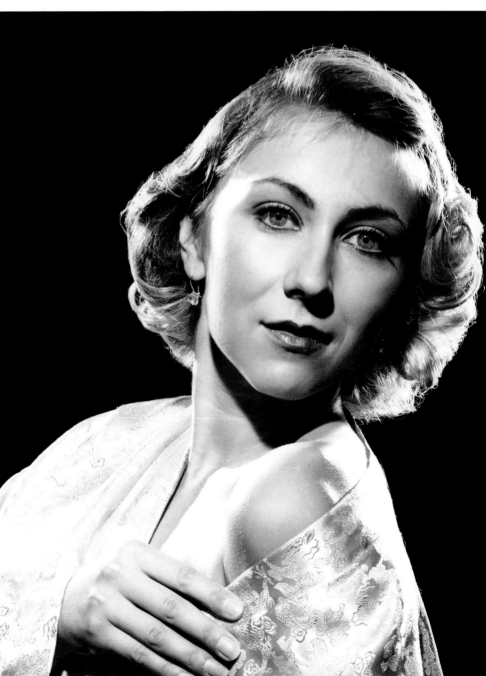

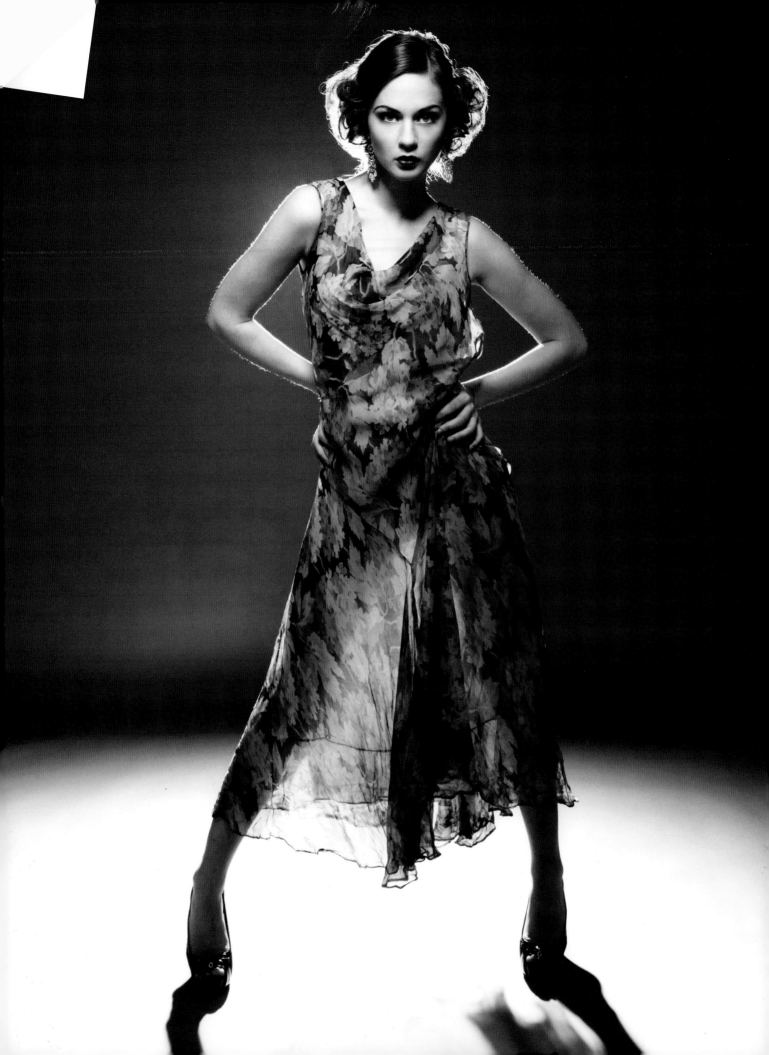

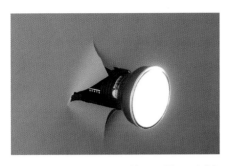

Above—Photo 3.13.
Facing page—Photo 3.14.

Strong Backlight and Flare

Let's go over the top once again for the first shots of the next set. I remember seeing an early photo of Mommie Dearest herself, Joan Crawford, backlit, with light streaming through her somewhat diaphanous gown, on an elegant art deco stairway. I don't have such a feature in my studio, and you probably don't either. You might be able to find such a location, but most clients will not want to pay the extra cost of a location shoot or be eye candy for the gawkers you'll surely attract.

A much simpler approach is to push a light through the background. If you were to just shoot a head and shoulders portrait, this would be easy—just set a light on a stand behind the model and make sure the model's shadow covers the camera. I use an overexposure of two stops over the main light to get the effect I want.

For full-length shots, you'll need to hide the strobe stand or it will be visible behind the model. First, measure the height of the light against the model, off set. I typically raise it until the reflector is aimed at the broadest part of her back. Make note of the height and find it on the back of the seamless background. Use a box cutter or X-Acto knife to cut an X into the paper, just an inch or two larger than the diameter of the light itself. Bring the stand up close and push the head through the paper, attaching the parabolic reflector afterward, just to keep the slits as small as possible. *Photo 3.13*

You can now bring your model onto the set and place her where you want her to be. Measure the strength of the light by placing the meter against her back and aiming it at the light. Power the main light to be two stops less than the backlight. In other words, if the backlight meters at f/11, power the main light to f/5.6 and set your camera accordingly. You can vary the spread of the light, of course, by inserting a grid into the reflector. If you do that, the amount of light hitting the floor will change and the look will be different, but that final look is totally up to you.

Below—Photo 3.15.

My main light was a beauty bowl with a 25 degree grid, positioned over the camera. The overall effect of the two lights working together is dramatic, sensual, and in keeping with Hollywood portraiture of the decade. *Photo 3.14*

I mentioned that, as long as the model's shadow covered the camera, there would be no problem with flare. What if you *wanted* the extra drama of flare? Early photographers avoided it because their lenses did not have the benefit of flare-suppressant coatings that are common in our better, contemporary glass, but we can use it to create additional drama in the image. You'll need to be a little careful, though, because if it's overdone, the resulting bright highlight and loss of contrast will kill the shot. Use your camera's LCD to determine how much flare your lens can handle, and work within that range. Your results may be beautiful. *Photo 3.15*

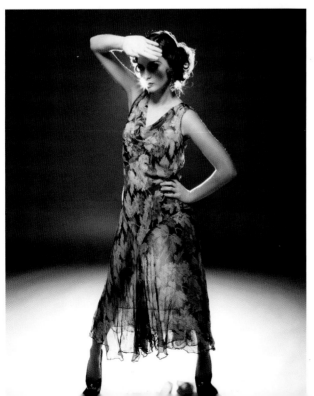

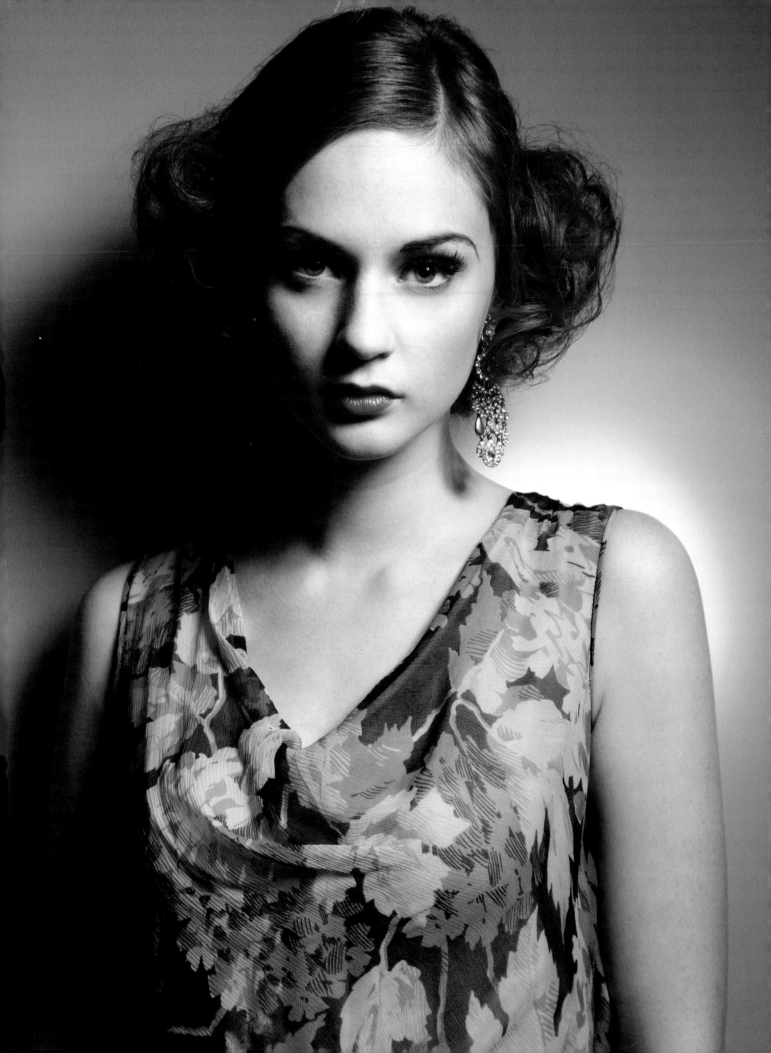

A Lighting Puzzle Solved

Even though I've been doing Hollywood lighting for many years, while doing further research, I found a lot of new effects to replicate. One trick I found especially endearing was that of a background highlight, aimed over the shoulder of the model, that didn't throw any extra light on the shoulder itself. A light like this would have been very difficult to control, and I couldn't think of a logical 1930s combination of background and foreground that would guarantee its success. It was one of the great mysteries of the Masters, perhaps, but I wanted to make it happen nonetheless.

I hung a 3x4-foot piece of $\frac{1}{4}$-inch milk-white Plexiglas acrylic behind where the model would be positioned. Behind it, I moved in a strobe with a parabolic reflector and a 10 degree grid, placed very close to the Plexi. This light was powered to $+\frac{1}{3}$ over the main light, a strobe with a beauty bowl. Now, as you've probably picked up from my other books (If you haven't read them, you really should buy them. I can't put everything I know into just one!), the distance of the light from the subject determines the softness of that light. I moved the beauty bowl back far enough to throw soft light with a defined shadow, racked it high enough to get a perfect nose shadow, and powered it $\frac{1}{3}$ stop below the background light. This reading became my working aperture. I also used a small piece of black Cinefoil on the background light (see *Christopher Grey's Advanced Lighting Techniques* for more about this product) to keep light from spreading to the other side of her neck. A small cardboard flag could also work nicely but might be harder to clamp into position.

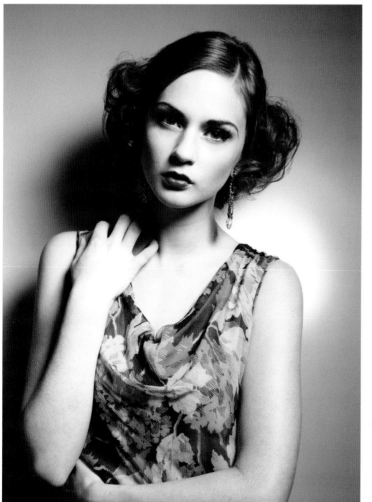

Facing page—Photo 3.16.
Below—Photo 3.17.

It took a number of test exposures to get this light positioned correctly, but the extra time was worth the effort. This final image is quite intriguing, mostly because of the backlight, but even more because the backlight is so difficult to figure out. Her shadow butts up against the background. Where does that light come from, anyway? *Photo 3.16*

It's entirely possible, as it is with most "off the wall" lighting techniques, that your clients will prefer a more contemporary twist to your lighting. The easiest thing to do with this scenario, as with many that utilize hard light, is to bring in a fill card on the shadow side. I moved a white bookend to about 3 feet from the frame edge at camera left to open up the shadows. Personally, I like the shadows. I think they are much more representative of early photography. However, this is a much better approach than using a second light for fill. I am a "simpler is better" kind of guy whenever possible. *Photo 3.17*

CREATING A FALSE WALL

Let's look at another great cheat. While working with a different model, I decided to do a hard light portrait against one of the pillars in the studio. I often change the color of the paint on my walls for different shots, as you probably know by now. This particular wall is now neutral gray, but the pillar the wall butts up to retains a mottled pattern created a few years ago. I also have a painted canvas background with similar colors.

If you could see behind the pillar, you might see the studio couch, a bunch of bookends against the wall, or my office door. This would simply not look great.

I mounted the tube with the background on a boom arm and moved it into position on the other side of the pillar, far enough away from the model so that she still had room to move. Light came from a single parabolic reflector, fitted with a 40 degree grid, aimed at her from about 6 feet away. The result is a perfect illusion, and it is what we do best. *Photo 3.18*

Left—Photo 3.18.

1940s—The Shorty Forties

Stylistically, hard light dominated soft, and both men and women were photographed with deep shadows.

Aptly named the "Shorty Forties" because World War II took up half the decade, the 1940s are still considered the Golden Age of Hollywood. Hurrell, Bull, and many other photographers were kept very busy. Aspiring stars arrived daily, and all needed photos to leave behind with studio casting agents. Although the majority of images were created in black & white, both color negative and positive films were gaining popularity as their quality increased and more color labs opened their doors.

Stylistically, hard light dominated soft, and both men and women were photographed with deep shadows. Fill light was used, but sparingly. You could almost say the '40s was the decade of no fill, although my personal opinion is that the hard shadow look is not for everyone. I've used an extra light for some of the images in this book, but only where it was called for to duplicate a style. I much prefer bringing in a white bookend for bounce light, as it allows me to make quick adjustments and doesn't produce a second catchlight in the model's eyes.

Going on location has been a staple of photography, no matter what decade you reference. Personally, I like the control I have when I'm working in the comfort of a studio where I have everything I need. I'd rather eliminate the studio background and replace it with an existing shot of something else.

Green Screen

I use green screen technology for this, as provided by the Ultimatte plug-in "Advantedge" (www.Ultimatte.com). This filter recognizes the totally unattractive colors necessary for green screen or blue screen photography and removes them, leaving a subject against a transparent background. There are other suppliers of software for this trick—you may even find some freeware options. There are several other software makers who claim their programs can remove any background. I'll leave it to you to test them, but based on a few that I've sampled, I believe Ultimatte is the best. You can download the full-featured program and try it for free.

I use this approach so often that I painted my primary shooting wall green, as well as part of the floor. Rather than buy special green screen paint (which runs about $100 per gallon and doesn't cover very well), I went to my local

hardware store and bought the ugliest green paint I could find—one that was close to the shade of the green screen paint. *Photo 4.1*

My first shot required three lights, but only one was directed at the model. A strip light softbox was positioned on each side of the background and feathered so the light was relatively consistent across the expanse. A black bookend was placed next to each box to gobo it off from the camera and eliminate any chance of flare. Ultimatte's software can deal with some discrepancy in light strength, but I try to keep it as even as I can without driving myself crazy. After metering the background light, I positioned my model about 10 feet from the wall to ensure that no green light would be bounced onto her and goboed off the two strip lights with black bookends.

The only exposure consideration beyond necessary depth of field was that the green screen background had to meter 1 stop less than the main. In other words, if the main light metered at f/8, the background had to meter at f/11. It might just be my imagination, but I think I get a cleaner subject outline if I do this. *Diagram 4A*

The model's light was a bare-tube strobe on a boom. It was swung up higher than usual because I'd planned to have the model tilt her head as she rose from the chair and wanted her nose shadow to be correct for closed-loop, slightly Rembrandt lighting. Any fill from this light is solely from bounce off the studio walls, a great reason to keep them as neutral as possible. *Photo 4.2*

Photo 4.1.

Top left—Diagram 4A. *Bottom left*—Photo 4.2. *Right*—Photo 4.3.

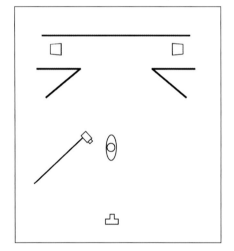

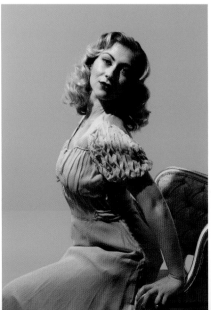

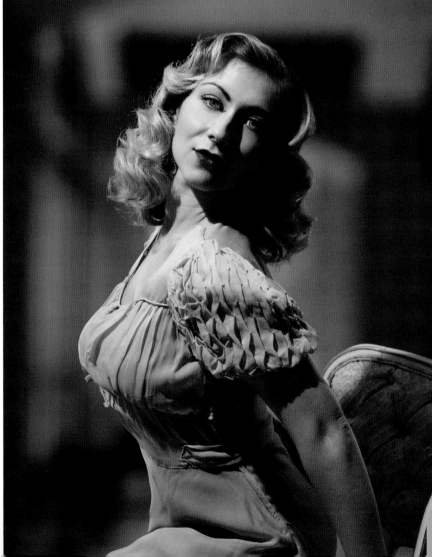

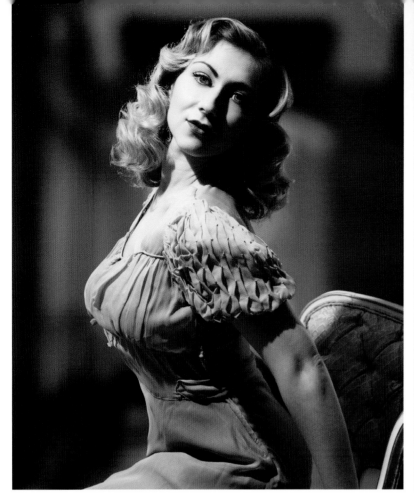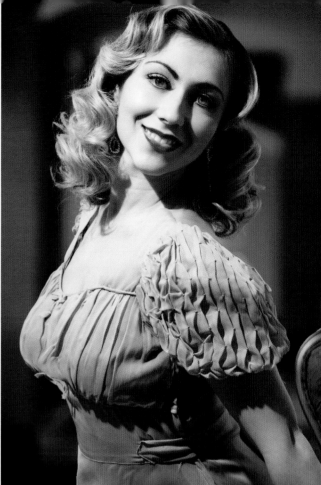

Left—Photo 4.4. *Right*—Photo 4.5.

Once the background is removed, the rest of the work is a piece of cake. Working with an image with a transparent background means retouching is quite easy, and I can work on areas with Photoshop's Liquefy tool that would distort an ordinary background while helping the model at the same time. I was able to quickly enhance her bust to Hollywood standards (you might want to check with your client before doing this) and push in the cloth of her dress where it fell away from her body, slimming her figure.

After retrieving one of my favorite backgrounds, I cropped her image and dragged it to the background. It required a little resizing to get it to where I felt it was most effective, about a thirty-second exercise. *Photo 4.3*

Finally, I converted the image to black & white and added a split-toning effect. Back in the day, photographers would routinely run fully fixed and washed prints through additional baths, replacing the silver with chemicals that produced color. Split toning occurred when two different toners were used. One might have been somewhat purple, the other more brown, and the effect varied with the amount of time a print sat in each bath. It was something that one learned from experience. Today, creating the effect is a lot easier (see chapter 7 for more information). *Photo 4.4*

I moved a white bookend into the shot, placing it on camera right, about 5 feet from the model, re-metered, and shot several more frames. Even at that distance, the addition of the bounced light slightly affected the exposure, and I had to adjust the strobe's power pack down $\frac{1}{10}$ stop to get back

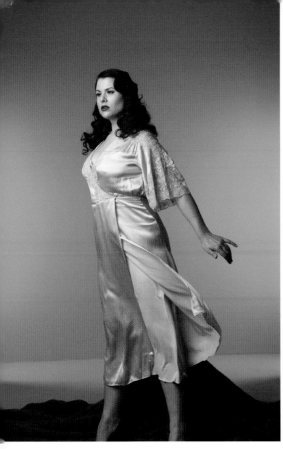

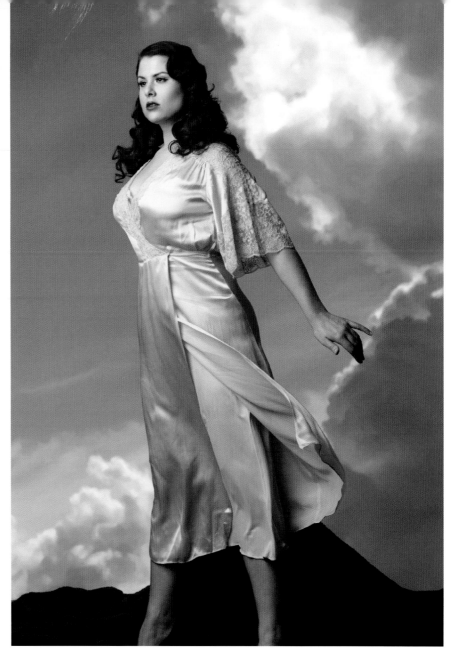

to my working aperture. This image will give you a good idea how slight, non-powered fill looks on the shadow side of her face. For comparison's sake, I chose not to add the split-toning effect to this image. It's beautiful either way. *Photo 4.5*

Hollywood often made use of existing movie sets and backdrops as backgrounds for stills. In fact, Hollywood photographers used every trick at their disposal, and why not? Foreground shapes were often created by simply covering an abstracted object (a box, perhaps, with an irregular shape on top of it) with cloth, painted canvas, or some other cover, and used as an indistinct prop. These shapes were never explained and may not have even been relevant to the idea behind the shot, but they were certainly effective when an actor was photographed in front of them.

In the '40s, actors were often photographed looking away from the camera. This position had become a standard in non-Hollywood studios as well,

Top left—Photo 4.6. *Bottom left*—Photo 4B. *Right*—Photo 4.7.

but Hollywood photographers used it in a more dramatic way. It was a tried and true pose that, thankfully (in my humble opinion), fell into obscurity in the '70s. While the pose is rather cheesy by contemporary standards, it's absolutely appropriate for retro work. *Photo 4.6*

Don't forget the axiom "what goes around, comes around," as our industry could see a resurgence of this position anytime in the future.

The main light for this shot was quite simple, a large, 4x6-foot softbox at camera left, raised high enough to create a nice nose shadow on my model's upturned face but angled down more steeply than usual to feather the light and keep the exposure uniform. A white bookend was placed about 6 feet to the right of the model, to add a little fill. *Diagram 4B*

After removing the green screen background, I added a shot of clouds that I reworked to resemble a softly painted canvas that might have been used in a Western or other "outdoor" movie. Both were combined, creating a wonderful and very successful shot, especially after conversion to black & white (an e-mail from the model proclaimed this image "AWESOME!"). *Photo 4.7*

Here's a little posing tip: When it is only partly visible, the subject's arm can appear disconnected from her body, so it's often helpful to the pose to have her hide her entire arm behind her body.

Moving away from green screen imagery, let's take a look at some more traditional studio work. Green screen, blue screen, or any subject-isolation software is nice if it works for you and your workflow, but whatever you settle on should be nothing more than another tool in the shed, ready for use at any time. I also understand that many of you do not have, or do not want to have, the obligation and learning curve that comes with new software. I'm fine with that. This book and other instructional photography guides (are my others on your list? Just askin'…) were written by folks who have been there and done that; we provide the building blocks and inspiration others need to find their personal styles and build successful careers.

> I've seen quite a few images incorporating a draped cloth background, usually with shiny or highlighted edges.

It may have happened sooner than the '40s, but I've seen quite a few images from that time incorporating a draped, cloth background, usually with shiny or highlighted edges. It's quite simple to do, as all you need is a piece of cloth that shows some degree of reflectivity when hit with light. Represented as an out-of-focus design behind the model, it will need to be long enough to hang and gracefully drape between two light stands or off a horizontal support and wide enough to fill the space behind the subject from above the top of the head to the bottom edge of the frame. When you go to a fabric store in search of such material, buy from the widest bolt you can find and buy a longer length than you think you'll need. You'll thank me later because you'll find many more uses for this piece of cloth, and some of them will require more length.

This image was created with only two lights. The main light, a beauty bowl with a 25 degree grid, was positioned close to and slightly to the left of the camera to produce a slightly variable nose shadow. I know I've said it before,

but to my mind the best thing you can do for any portrait is to create a perfectly sloping nose shadow. The only exceptions to this, of course, would be if you were to seek to break this "rule" and introduce shadows where contemporary tastes indicate you shouldn't, a technique I've referred to in several chapters. It's your call, but your approach to the shot should be determined by a conversation with your client and a portfolio viewing of previously produced images before you begin the shoot.

My second light was a parabolic fitted with a 40 degree grid. The grid was wide enough to light both the background cloth and my model's head without flaring onto my lens. It was set behind the model and angled slightly toward the camera, powered one stop over the main light as measured at the top of her head. The object here was to light both the background cloth and the model's hair but to keep light from spilling over the top of the model's head. The first place any additional light coming over the top would hit would be the bridge of her nose, and that would be bad. Additional light on the top of the nose would make that part of her brighter than the rest. Her nose would look larger, somewhat bulbous, and out of place. A sale killer for sure.

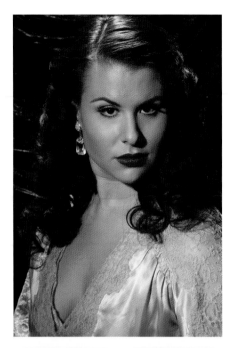

Attitude is key for the success of any retro shoot. I suggested my model assume an attitude of regality, the notion that she is above anything this world could offer her, an attitude many Hollywood stars of that time enjoyed on a daily basis. Models and clients both will enjoy this mind-set, as the makeup and wardrobe will help them get into the act and become "stars" in the minds of the viewers. A direction like this almost always works, but it's up to you to make it happen if your first suggestions don't get you what you want. *Photo 4.8*

I loved the lighting but wanted to see more highlights in the model's hair because I felt it would add to the value of the shot. I duplicated the layer in Photoshop and set the blending mode to Screen. I created a black mask and painted through it with white at 20% opacity, gradually and softly revealing the brighter highlights of the second layer. I also brightened her eyes and selected areas of the background. When I was satisfied the mask was showing what I wished to see, I duplicated the Screen layer again, brightening the highlights even more. This is the kind of work that would have taken a skilled darkroom technician several test prints to figure out—yet it took only a few minutes in Photoshop. *Photo 4.9*

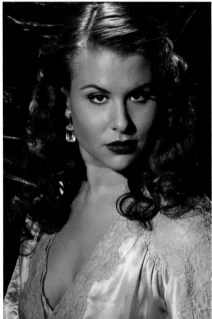

Top—Photo 4.8. *Bottom*—Photo 4.9.

Another device that was commonly used in the 1940s was the "drape," a piece of cloth, usually black, that wrapped around the model, allowing for a dramatic, bare-shouldered look that was quite sexy for its day. The cloth was most often just held in place by a gracefully placed hand, but there were commercial drapes available (and there still may be). Some would drape in a pre-designed V shape, while others featured an elastic edge. I used a battered piece of black velour that's been living in the studio prop room for years but still looks elegant when artfully placed.

It's not a hard-and-fast "rule," but most portraiture is lit with the main light coming from one direction and the hair light from the opposite. The primary purpose of this setup is to be certain that tonal merger, where shadows from the subject blend into the background, does not happen. As we've seen many times, and as I've said, retro Hollywood photographers rarely gave a rat's backside for rules.

Both of the lights I used for this scenario were fitted with grids, a 40 degree on the main light and a 20 degree grid on the hair light. The hair light was powered $\frac{1}{3}$ stop brighter than the main.

I repeated the same trick as before, duplicating the layer, etc., but did not paint through the mask as much as before. I wanted a hint of extra highlight and a little more personality in her visible eye, nothing more. *Photo 4.10*

After converting the image to black & white, I rotated it slightly and cropped it to 8x10 inches. Thanks to a wonderful retro hairstyle, this image could easily pass for vintage. *Photo 4.11*

Next up, we have a shot made with the model in a 1940s coatdress. The setup for this shot would be a little more difficult. I had a feeling this model could present some serious attitude, and I wanted to explore that possibility. The vintage dress and hat were both black, as was my model's hair. I wanted a dramatic background, which also meant black. Black and black on black can be a nightmare photographically, but I knew that if I went over the top with the light, I could pull this off.

I placed two lights on separate boom arms. The first was a 40 degree grid, aimed at the background and positioned to create a vignette at the edges of the frame. I overpowered the light, three stops over what the main light

Left—Photo 4.10. *Right*—Photo 4.11.

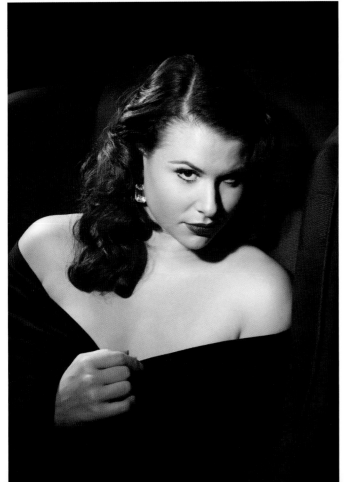
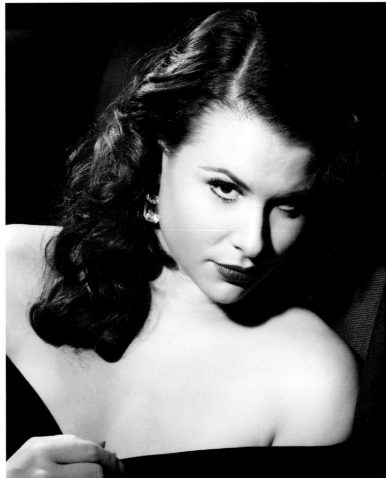

would have to be, to create a light-gray background that would immediately fall off to black at the edges. To my mind, there is no other way to do this, certainly none that looks as vintage as this.

The second light carried a 30 degree grid and was positioned over the top of the model's head, just far enough back so that she had some room to move without additional light spilling over the top of her head and onto the bridge of her nose, a terrible place for light. This light was powered to the same f/stop, three stops above what my working aperture would be.

The main light was a strobe with a 20 degree grid, on a stand and aimed at the center of the model's face. I knew it would fall off rapidly at the edge of the grid line, becoming essentially useless beyond its range. I set a second light, a beauty bowl (one without a grid, an unusual move for me), behind the main light and powered to two stops under the main. Remember that these lights must be metered individually to get the correct ratio, then together to get the correct working aperture. If you do not do so, you risk serious and unfixable overexposure. If the combined meter reading is not a whole f/stop or a perfect third, adjust the fill light (the beauty bowl in this case). The slight change in the fill to main light ratio will not dramatically affect your images. *Diagram 4C*

You can't just set this up and get the results I did. It takes a little time to get things right. One of the great advantages of digital photography is that you can take a shot and assess its success in terms of light placement. This is not to say that you can use your camera's LCD as a light meter. You cannot, because it's just not that accurate. When you calibrate your light meter, and know you can trust it, you can achieve spectacular results that will make your

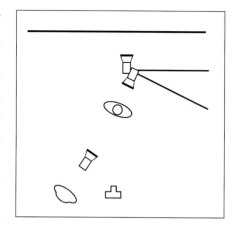

Above—Diagram 4C.

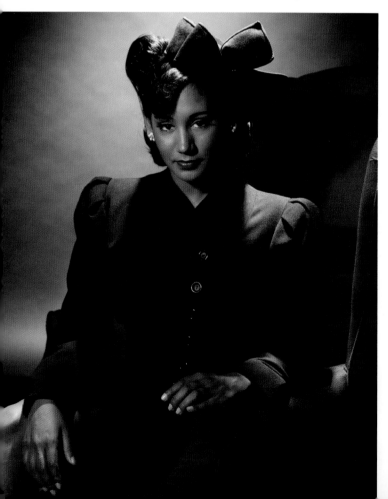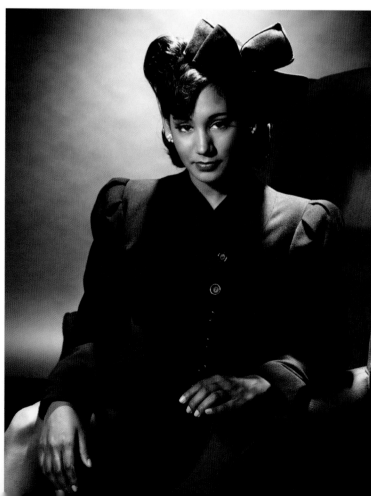

Left—Photo 4.12. *Right*—Photo 4.13.

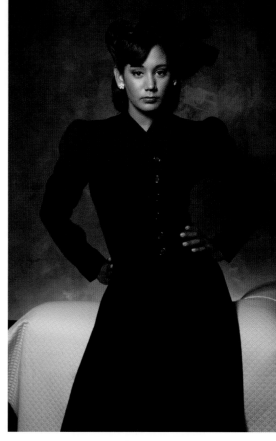

Right—Photo 4.14.

Attitude can be bold or subtle, and, photographically speaking, it is usually a combination of each.

competition kneel before you. Check and meter each light individually and then together. Note where source lights overlap and either move them so they won't influence each other or make them work as a system. Check and re-check everything before going for the money shot.

I used my camera's LCD to check the position of the lights, rather than their ratio. In this regard, the LCD is a great tool. It took just a few minutes to shoot, view, and move the background light to get it exactly where I wanted it.

With my model in place, I instructed her as to what I expected for attitude. Attitude can be bold or subtle, and, photographically speaking, it is usually a combination of each, with some aspects of the subject (her body position) being bold while others (her hands) are more subtle. When doing a retro Hollywood portrait I almost always instruct my clients to assume an attitude of regality, as if they were among the Chosen Few of the world. It rarely fails because they've come to me to be photographed with that very attitude and are willing to comply because they're paying for the shot and want it to be successful, a strong motivator for anyone.

Just as I always do, I shot more than a hundred frames of this pose, expanding on it as I directed the model to give me what I wanted. This is one of the beautiful benefits of shooting digitally. It's obvious that more images equal more sales opportunities, but you're really creating a form of visual insurance because subtle nuances from shot to shot mean your final edit will be full of great stuff. I love it when clients tell me their decision was really difficult.

My model did such a terrific job with this that even my final print decision was difficult, but the final shot looks great in color or black & white. *Photos 4.12 and 4.13*

My second shot in this series was a little more sedate and was meant to include a retro prop, a couch. I didn't want the "couch" to be anything more than a suggestion, a hint of a decade long past. Props, no matter how much time you need to spend to make them happen, are nothing more. They are there to make the image work and serve no other purpose. With that in mind, cheating is perfectly fine. After all, we are in a business predicated on visual lies and BS, smoke and mirrors.

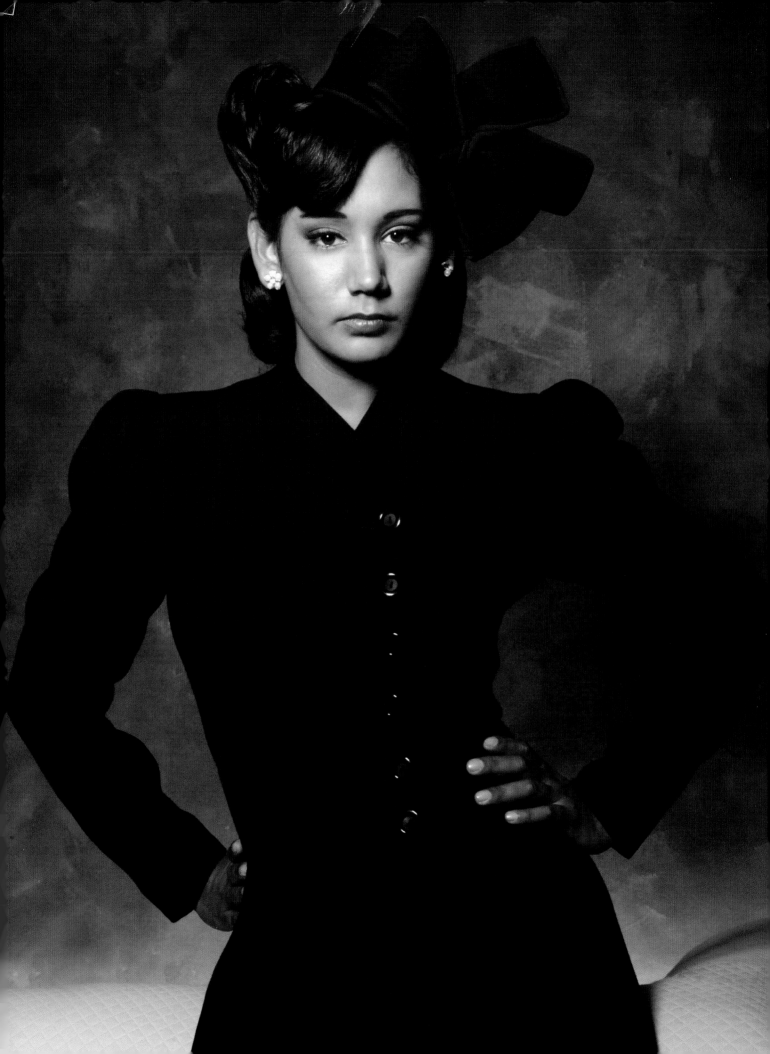

Facing page—Photo 4.15.

I bought a yard of a retro-looking upholstery material at my local fabric store. I knew I would have to retouch a couple of small details, but that's just part of the game. *Photo 4.14*

My lighting was quite simple. I used a basic parabolic as a main light and placed a strip light softbox at the base of the backdrop. The softbox was powered up rather high, but only because it was almost butted up to the drop. I wanted a little brightness at the bottom and a quick falloff. This will naturally happen when you place any light close to the subject or background, and, like I did, you can use your light meter to determine the position of an equal exposure. Move the softbox closer to or farther away from the background to change the falloff distance.

I fixed the seam on the right, extended the top of the left side, and did the usual retouching on the model herself. Her attitude, which I love, came from a sideline suggestion from the hairstylist who said, "Just be a badass, honey. You'll look great." She was and she does. *Photo 4.15*

LIGHTING FOR POWER

If you are hired to produce a shot for an executive, an editorial client, or just a guy off the street who wants a power portrait, 1940s lighting is the way to go. There's something about the lack of detail in shadow areas that adds strength but requires lighting that shows the shape of the body that's in the shadows.

We did our shoot with vintage 1940s clothing, just to stay within the scope of this book, but take a look at these images and visualize how they might look with a subject (either male of female) who needs to look friendly, powerful, and contemporary. I'll say here that this lighting may not be politically correct for many photos. I'll also say that I despise the politically correct concept, a point that I will open any workshop monologue with. I've been in advertising all my life and, while I feel the impact of that industry has been diluted by political correctness, I also know that whatever I'm hired to do is predicated on my ability to turn a client into a visual lie. That client may be the mousiest person on earth, but it will be my job to make him or her (now, that's "PC") look powerful. Or they may be among the most powerful people, but my job will be to make them look "normal." Should you try my lighting, my job becomes your job.

In the '40s, when minimal fill was the standard, what was not lit was as important as what was lit. Photographers made certain that the subject's form was at least silhouetted by the background light. This was the beginning of the style dubbed "film noir," essentially, "dark film."

For my first series, I prepped my background light, a strobe on a boom arm, by adding a homemade Cinefoil snoot and bending it into a shape that would produce a triangular blast of light behind the chair the model would occupy.

My main light was a beauty bowl with a 25 degree grid, set about 3 feet to the left of the camera. It was not set very high because I wanted to light

In the '40s, when minimal fill was the standard, what was not lit was as important as what was lit.

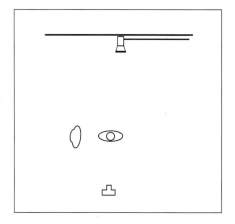

Top left—Photo 4.16. *Top right*—Diagram 4D. *Bottom*—Photo 4.17. *Facing page*—Photo 4.18.

under his brow. Since only half his face would be seen, I wanted shadow to obscure his visible eye. *Diagram 4D*

Once my subject was in position, I directed him through a number of subtle changes, slight smiles to more stern expressions, until I was satisfied that I'd worked that first pose to death. The result is both powerful and enigmatic. *Photo 4.16*

I asked him to turn his head slightly to his right, toward the main light. Doing so allowed a bit of light to fall across his otherwise shadowed eye and cheek. I like this image because his position adds a bit of friendliness to the shot but the nose shadow, while in keeping with 1940s style, is too broad for contemporary work. You may want to raise the main light, even bring it around and closer to the camera, to modernize the concept. *Photo 4.17*

I wanted to do a second series that represented a different kind of power, something that appeared more considerate and benign. Psychologically, if someone leans away from you, they are less of a perceived threat, even more so if they are sitting in a comfortable position and wrapped in a chair.

After removing the Cinefoil snoot, I raised the light higher and changed its angle, aiming it to fall straight down but more in front of the model. I also moved the main light with the grid much closer to him, less than 2 feet away, and positioned it just over the top of the chair's wing.

Since the top of his shaved head would be closest to the light, it would be the brightest part of the shot. I hung a small piece of black foamcore on an accessory arm and moved it in to slightly shadow the top of his head, directing the emphasis of the shot to his eyes. Note that his right eye is at the intersection of the most readily seen Rule of Thirds juncture. You can't help but look there. *Photo 4.18*

I backed the camera off a bit and opened up the scene. With his fingers folded together he presents a perfect Hollywood persona: controlled, confident, and powerful. He also looks like any one of a number of B-movie villains. *Photo 4.19*

Left—Photo 4.19.

1950s—The Fabulous Fifties

Photography as a medium went through some astounding changes in the '50s. Studio strobes were more commonplace, yet rather dangerous, and softer light began to replace the harder light from previous decades. Color films and papers were significantly improved and, as more photographers worked in color, costs came down.

Arguably, the greatest contribution we saw from the 1950s was not to color photography, but rather to the national color palette itself. After the drab years of war and rationing, America went design and color crazy, with pinks and greens leading the way. One of my favorite movies from that era is *Forbidden Planet,* a 1956 epic about an invisible menace on a distant planet. Set on the mythical Altair IV, a spaceship lands and meets a reclusive Earth scientist and his daughter. Strangely, their home is decorated in many shades of pink and green, from the flat, 1950s-style couches to the costumes.

Photography as a medium went through some astounding changes in the '50s.

Using Like Colors

In print, art directors often favored backgrounds and props similar in color to the wardrobe a subject would be wearing. It may seem odd at first because today's backgrounds are generally more sedate and neutral, but the effect is quite striking and should be used to set the stage for a believable retro portrait.

I began my first set by centering two large softboxes about 4 feet in front of the chair my model would be using as a prop. The boxes were placed at diagonals to each other, overlapping slightly at the bottom corner. *Photo 5.1*

Right—Photo 5.1.

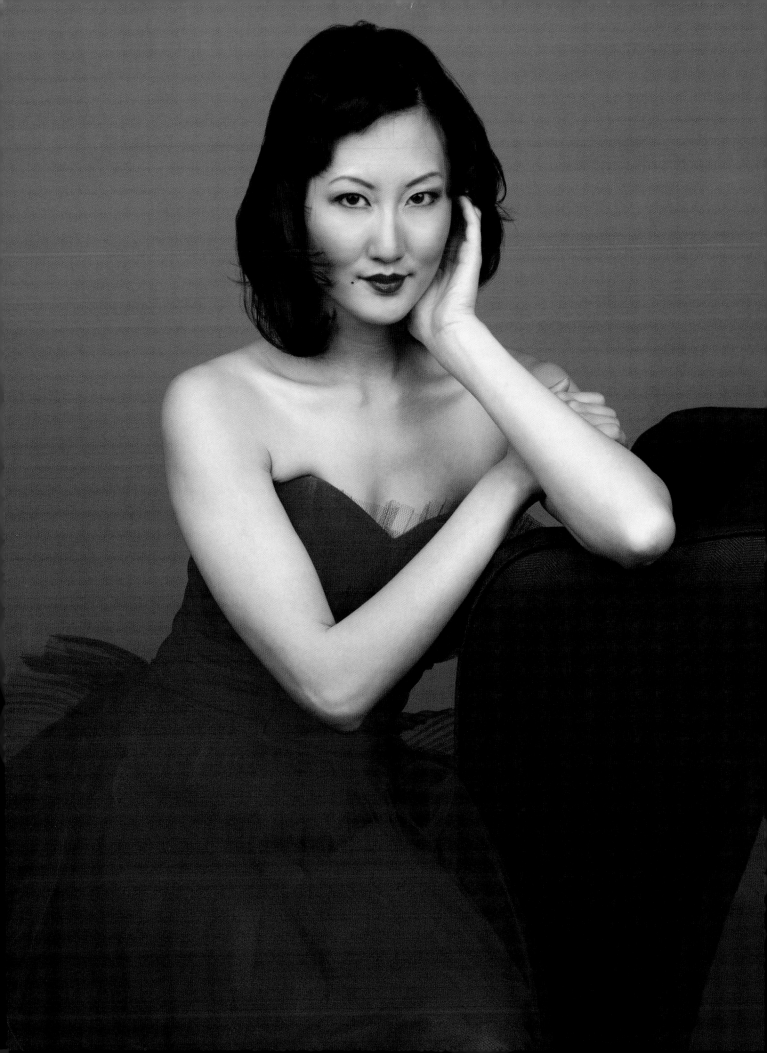

The size of the softboxes guaranteed a very soft light. Even though the chair itself was only about 4 feet from the background, the size of the source meant any shadow would be so soft as to be unrecognizable. Tipping the boxes diagonally allowed me to shoot through the "tunnel" and from behind the lights.

After my lights were placed, I metered each one separately, with the other completely turned off, from where my model's face would be. Once the first light was set to an f/stop that I liked, it was turned off. The remaining light was adjusted to the same power and f/stop. The first light was turned back on and both lights were metered together to produce the working aperture, f/13 in this case.

Once the model was out of makeup and into her wardrobe, the exposure was metered with her in place and the chair was moved slightly so her face would receive a perfect f/13.

Tipping the boxes diagonally allowed me to shoot through the "tunnel" and from behind the lights.

I've worked with this model many times (you may have noticed her on the cover of *Christopher Grey's Advanced Lighting Techniques*), and I enjoy her sessions not only because she's intelligent and lovely but because she's capable of a subtle range of attitudes that elude many others—and can produce those looks at will. This first image was made with only the two softboxes. *Photo 5.2*

Next, I added a medium softbox at camera left, placing it closer to the background than the model. I wanted to create a very soft, almost unseen, highlight on her side, so the new light was powered to the same f/stop as the two main lights. Given the wraparound nature of the light produced by the two softboxes, the highlight is only visible where it crosses light from the mains—almost nowhere. Light plus light equals brighter light. *Photos 5.3 and 5.4*

Facing page—Photo 5.2.
Right—Photo 5.3.

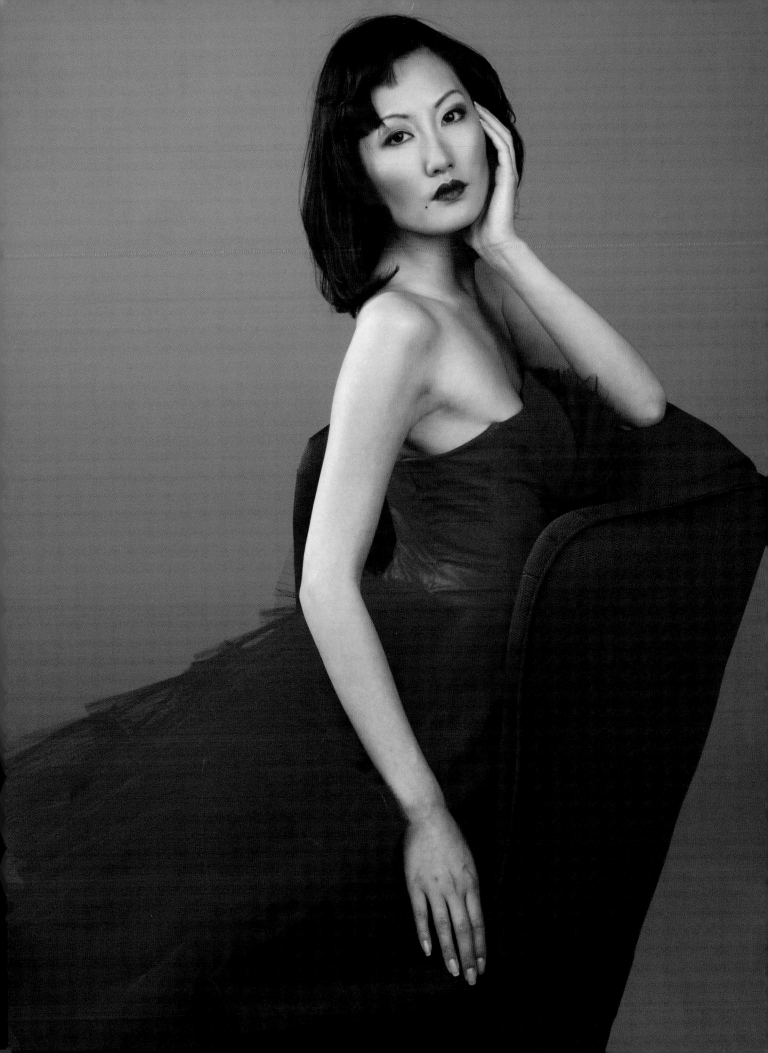

CONTEMPORIZING 1950S LIGHTING

Before we go any further with colored backgrounds, let me show you an easy way to contemporize a shot like this.

I kept the two softboxes where they were but added a hair light, a beauty bowl fitted with a 25 degree grid to direct the light onto the model without allowing it to spill into my lens. It was powered $+^1/_3$ stop over the main lights. I used two pushpins to anchor a chunk of black indoor/outdoor carpet on the wall behind the model. I knew the carpet would absorb much more light than black paper at this distance (4 feet) behind the model. In fact, it soaked up almost 100 percent of the light. *Photo 5.5*

The result against black loses a bit of its retro authenticity but none of its visual power. *Photo 5.6*

Now, back to our chapter.

Facing page—Photo 5.4.
Above—Photo 5.5. *Right*—Photo 5.6.

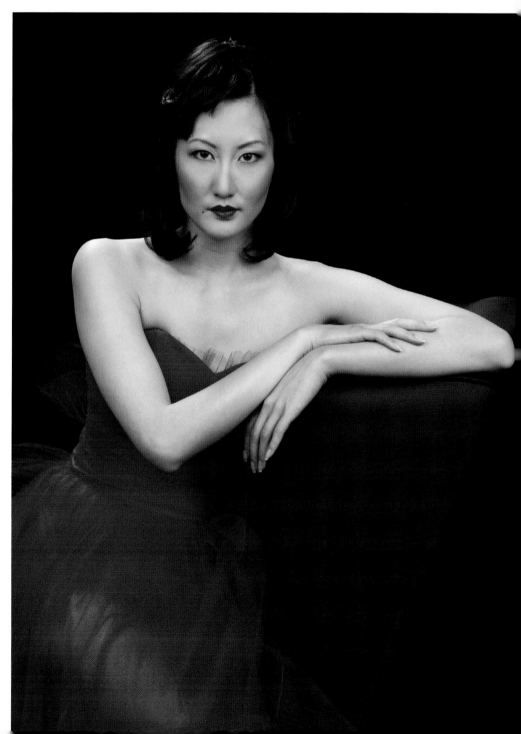

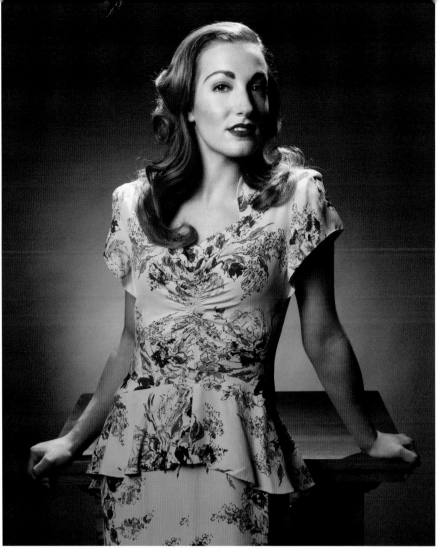

COMPLEMENTARY BACKGROUNDS

Not every shot used soft light, and not every shot utilized backgrounds similar to the wardrobe. Frequently, photographers set backgrounds that were complementary (the opposite color) to the subject's clothing.

Many lighting styles evolved in the '50s as well, including one that used hard and soft light at the same time. I've written many times in other books and articles about how to use a double main light to get unique, spectacular effects but, fortunately, there are many ways to create it that are still discoverable, something that's great for me because I love the look (you will too).

I began by setting a medium softbox approximately 8 feet from where my model would be standing. I then placed a beauty bowl, fitted with a 25 degree grid, about 3 feet in front of it. Both lights were angled the same, with the beauty bowl centered on the softbox. This meant the softbox had to be higher than the reflector to get the same angle to the model. *Photo 5.7*

It's important to meter each light separately, then together to get the working aperture. With the model in place, I metered the beauty bowl first, powering it to a perfect f/8. Whenever you work with a gridded light, it's necessary to meter the center of the hottest light that falls on the model, because the light falls off dramatically from that point, especially when using a tight grid. In this case, I centered the light on the model and measured the light from the center of her face, right between her eyes.

After turning it off, I powered and metered the softbox to f/4, two stops less than the parabolic, placing the meter in the conventional position under

Top left—Photo 5.7. *Bottom left*—Diagram 5A. *Above*—Photo 5.8.

the chin. With both lights on, another reading was made to get my working aperture.

For accent and "punch," I set a light with a standard parabolic and 20 degree grid aimed at the background, directly behind the model. This light was powered to 1 stop over the working aperture, as measured at the hot spot, guaranteeing a spot of light brighter than the background.

I placed another light, with a 40 degree grid on a boom, directly above and slightly behind the model, aimed at her shoulders. This light would illuminate her a bit like an aura, accenting her shape and posture. *Diagram 5A*

The images I got with this scenario are superb. A wide spot of light accented her face, shoulders, and upper chest, falling off to softer light below.

Right—Photo 5.9.

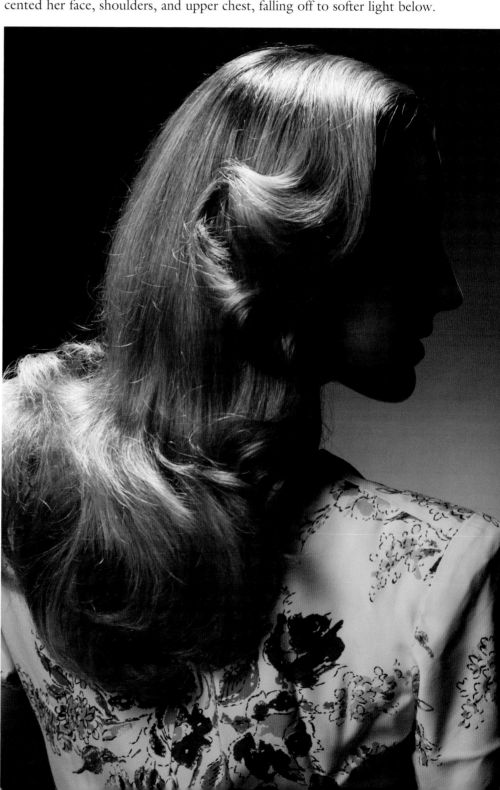

The background light produced a complementary color to her wardrobe at the spot, and the hair light allowed her retro hairstyle to absolutely shine. *Photo 5.8*

As I was directing her through a pose change, I saw an opportunity to highlight the fabulous hairstyle she'd been given. Don LaCourse, the professional hairdresser, has a passion for retro hairstyles that certainly came through on this shoot (and many others in this book and in the video available on my web site). *Photo 5.9*

I moved the hair light more to camera left, taking it almost totally off the camera-right side of her face. Her face now softly fell into shadow but still held detail because of the softbox (light from the beauty bowl alone would not have allowed this). What a gorgeous shot!

COMPLEMENTARY BACKROUNDS, TAKE TWO

While Don was restyling her hair, I took the red sweep down, revealing my large green screen wall behind it. I wanted to try the same two-light main scenario but wanted to give my model harder shadows from the grid. I removed the beauty bowl and substituted a parabolic with a 20 degree grid.

Unlike the previous example, where both main lights were set at equal angles, I racked the parabolic much higher than the softbox. I had two reasons for doing so. I wanted to highlight her new hairstyle, specifically the top curls Don built into it, but I also wanted a slightly longer, perfect nose shadow across my model's face which would also contour her eyes and cheeks in a way often seen in late '40s and early '50s imagery. *Photo 5.10*

The softbox was set an additional $\frac{1}{3}$ stop less, so, while my initial meter reading was f/16 from the parabolic, the softbox was powered to f/8. Again, both were metered together to get the final, working aperture, f/18.

The final result, reminiscent of Betty Grable, is nothing short of fantastic. *Photo 5.11*

Left—Photo 5.10. *Facing page*—Photo 5.11.

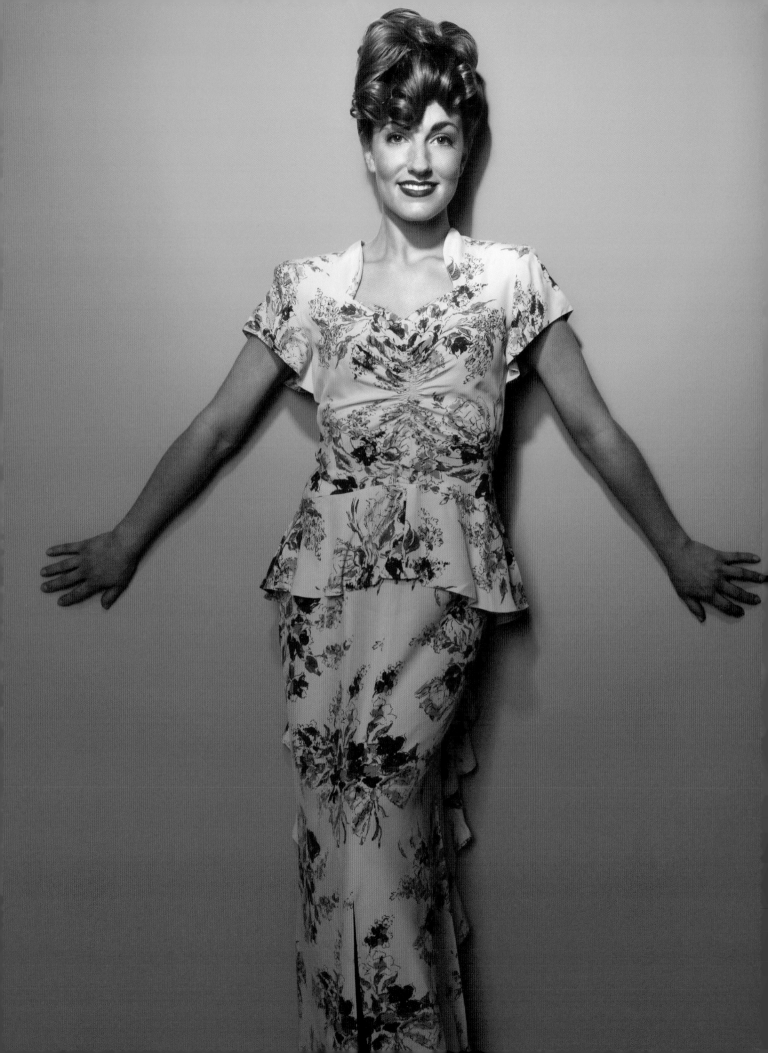

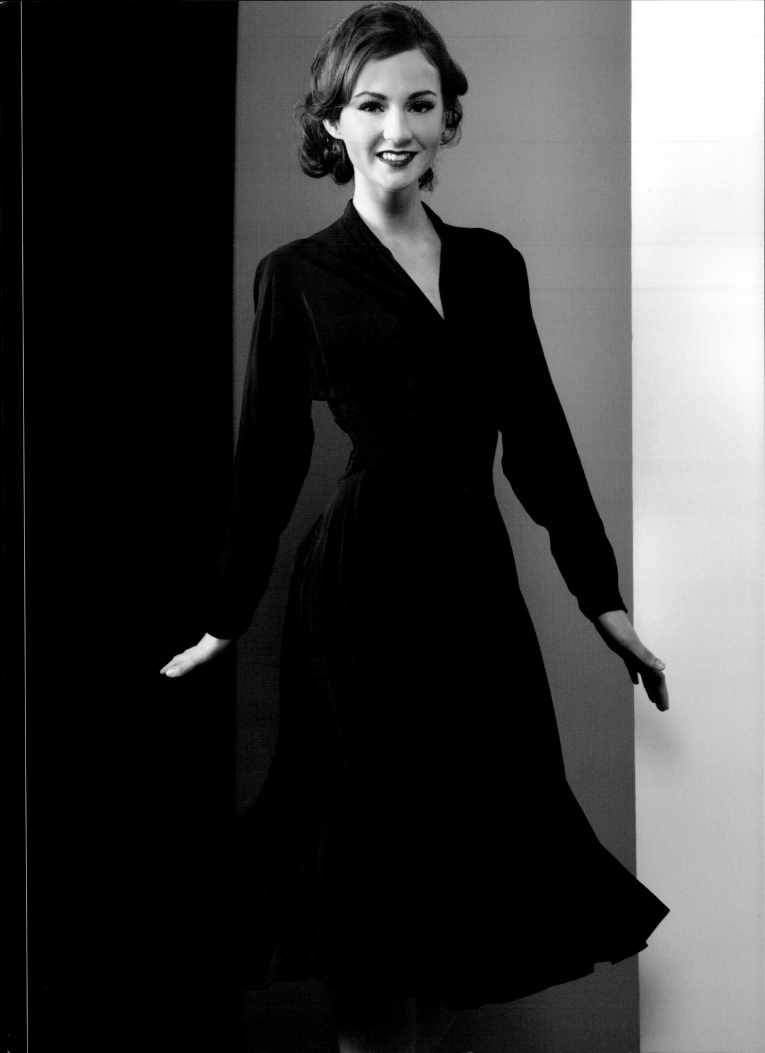

Facing page—Photo 5.12.
Above—Diagram 5B.

1950s Fashion

Fashion photography in the '50s went through the same changes as retro Hollywood. Some of it was softer, taking advantage of strobes and softening devices such as scrims and screens. Because models could now move within the frame and be frozen in motion by strobe light, movement became an important tool.

I've seen many examples of multi-toned backgrounds in retro images, usually a two-panel combination of black, white, or gray, but there were examples of three-panel combinations as well. Most of the examples I looked at were in black and white, but the few color images I've seen confirm the black/white/gray scenario.

My background was simply made. I tacked a piece of black indoor/outdoor carpet to my gray wall and moved a white bookend in on the other side. A black bookend was used to block any light from hitting the black carpet. Lighting was provided by two medium softboxes, one on each side of the model and aimed toward her. The box at camera left was powered $1/3$ stop brighter than the other. *Diagram 5B*

Cross lighting with softboxes can be quite versatile. You'll need to pay attention to where the shadows fall, and adjust either light if you see a shadow pattern that doesn't work for the model. Also, watch the model's nose. Cross light can make a nose look larger than it is, because it hits it from the side, without a contouring shadow on the other side to balance the form. *Photo 5.12*

When you change the softboxes to a diagonal position (e.g., to the 2:00 and 8:00 positions relative to the model), you'll have even more versatility. Power them equally, and the model can now turn to either side and either profile and remain beautifully lit. *Photos 5.13 and 5.14*

Left—Photo 5.13. *Right*—Photo 5.14.

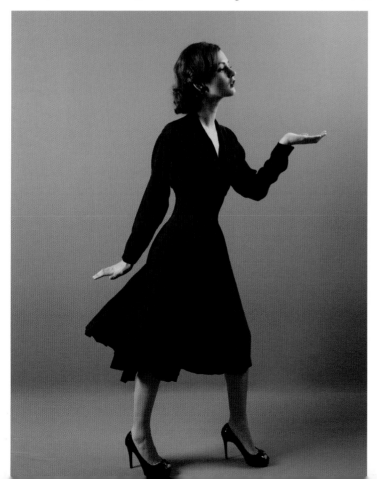

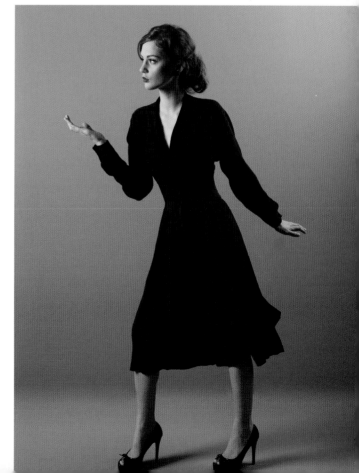

Remember that you want to be as easy on yourself as possible. This means building lighting scenarios that give you flexibility and allow you to present your subject with a variety of looks. I try to plan ahead and have a basic scenario roughed in ahead of time, even setting the power of the lights. When the model is ready it usually only takes a few minor tweaks and we're good to go.

USING SHADOW

Like every other decade, fashion photography utilized shadow as part of the composition. I wanted to create a nice, hard shadow that would work with exaggerated movement. I also wanted light that would be of a constant

Below—Photo 5.15.

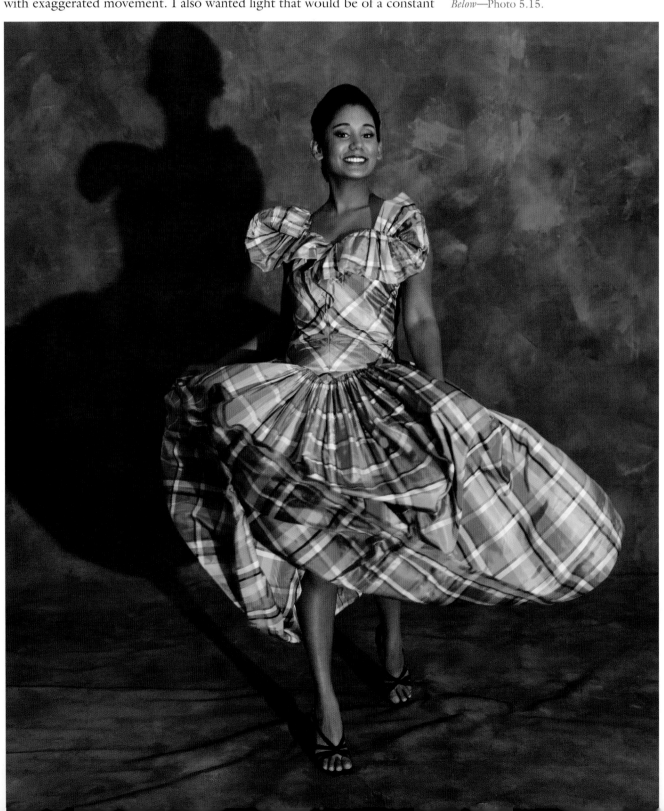

strength over several feet of background and foreground, so the model would have room to move around and give me the energy I expected.

To get the constant exposure I wanted, I set a single strobe on a short stand about 18 feet away from where my model was standing, and raised it until I had a shadow height that I liked. Such a distance guarantees a certain amount of "depth of light," a secondary part of the Inverse Square Law that can be exploited to your advantage. You see, if light falls off faster the closer you are to a subject, it stands to reason that it will fall off gradually if the light is farther away.

Another benefit to that distance is that the light has become a very small source and will throw a hard and cleanly defined shadow from her feet all the way back to the canvas drop. *Photo 5.15*

STOPPING ACTION

You may think your strobes will stop this action, but you may be wrong. Whenever you increase power from the generator's lowest level, you're actually increasing the duration of the flash. I was working at f/6.3, not quite the middle of my lens' aperture range, and not asking my 2400 watt-second pack for a lot of power, but a quick inspection indicated that the flash duration was too long to stop all motion. As you can see, the most rapidly moving piece of the model's skirt is actually blurred. *Photo 5.16*

The solution, and it's an easy one, is to turn the generator's power to its lowest setting and increase the ISO on the camera until you get an aperture you can live with. The lowest power will give you the shortest flash duration. In my case, it was increased from 100 to 640, and I settled at f/4. If you look closely at the skirt in the above image, you'll see that all motion has been arrested. *Photo 5.17*

When you increase power from the generator's lowest level, you're increasing the duration of the flash.

It's possible you'll encounter a problem with color balance when you radically turn down the power while increasing the ISO. When you compare the two images, you'll notice the exposure is the same but the color is not. This is a common problem, but it can be easily fixed by doing a custom white balance before beginning the new set. I avoided it deliberately, as I wanted you to see what might happen if you neglect to use that particular tool. In a way, I was lucky my image's color shifted to red, which warmed the image. It could have just as easily been blue, depending on the gear. *Photo 5.18*

Left—Photo 5.18.

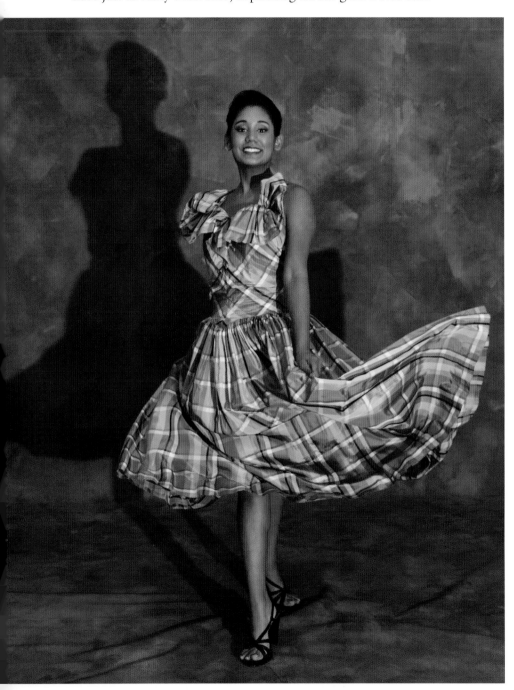

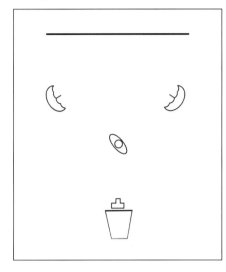

Top—Diagram 5C. *Bottom*—Photo 5.19.

"Temptation" as a Theme

Creating a sexual aura around a woman is nothing new. Artists have been doing that since the beginning of time. "Temptation" is a frequent theme, often with some reference to Adam and Eve.

Since I first began offering classic lighting and vintage portraiture I've spent countless hours looking at the work of early photographers and graphic artists, studying the poses and lighting, looking for clues that would aid my own efforts and make my work more believable. You should do that as well. There's a rich history out there just waiting for you to discover it.

I remembered a shot that included a classic reference to temptation, an apple and a beautiful woman, and I wanted to re-create it. The original, as I recall, was shot on a light-gray background that I felt was a bit muddy for the shot. I decided to clean it up by shooting on white and eliminating any foreground or background areas that were not perfectly white. When you do this, of course, you must leave (or create) a "contact" shadow wherever the model comes in contact with the floor, or she will look as though she's floating in space.

My main light was a medium softbox, centered above where my camera would be. My model would be positioned about 8 feet from the white seamless background.

The background was lit with two umbrellas, one on each side, and aimed at the center of the paper. They were placed about 4 feet from the sweep, which meant that some of the light would splash back toward the model and help whiten the paper behind and around her. *Diagram 5C*

With my model in position, I metered the light from the softbox and powered each of the two umbrellas to 2 stops over that reading.

Because of the distance between the model and the background, as well as the width of the shot, I knew I'd see the base of each light stand in the background. Neither of them intruded into the image area, so it would be a simple task to erase them in Photoshop. *Photo 5.19*

PINUPS

Pinups were incredibly popular, and still are. Women love them, especially when the retro look is perfectly done. Some, who wouldn't dream of being photographed in their underwear, will happily don a bullet bra and girdle, gloves, and hose to get this look. I have it on good authority that their spouses or boyfriends like the results as much as they do.

While we were waiting for her curls to set, I sent the model into the dressing room to put on her wardrobe. I thought it would be great fun to do some shots with her hair in curls, like she was getting ready for a typical 1950s night out—or just getting ready to cook dinner. It was sometimes hard to tell in the '50s.

Left—Photo 5.20.

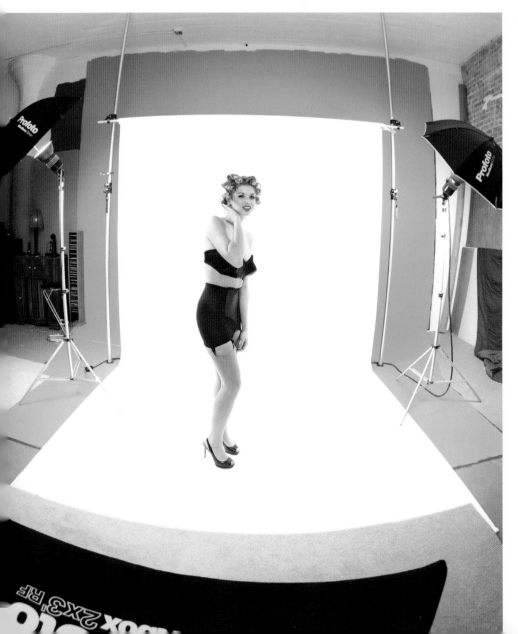

Right—Photo 5.21.

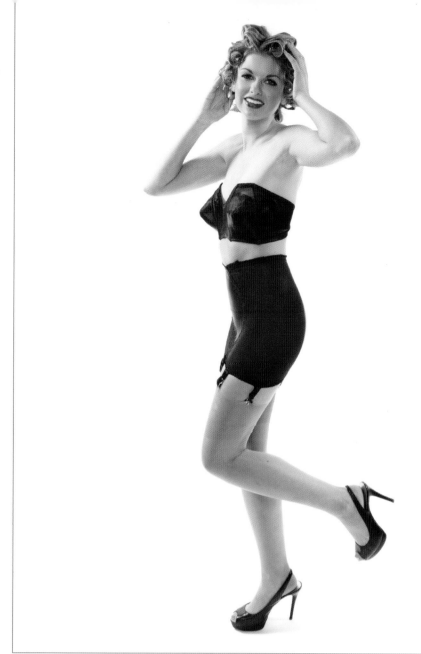

My lighting was similar to the last example, except that I turned the camera-left umbrella so its light would splash onto her front, giving the shot a little more contour. I also added a 2x3-foot softbox, set on the floor below the medium main light and aimed at the model. This light was powered down two stops from the main and would add fill by opening up the shadows. *Photo 5.20*

When the model emerged from the dressing room, the entire crew cracked up. She too was laughing at the absurdity of the wardrobe and the fact that, once upon a time, it was standard equipment. *Photo 5.21*

I guess that if this shot tells us anything it's that you should always be ready to exploit a situation. For most women, a shoot like this with retro wardrobe, makeup, and hairstyling will be a once-in-a-lifetime event. She may buy many images, so it's in your best interest to provide as many choices as possible.

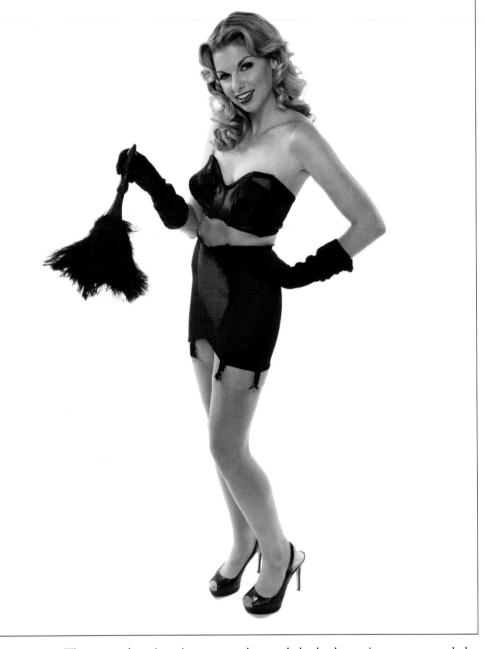

The extra shooting time meant her curls had a long time to set, and the resulting comb out was perfect. She went back into the dressing room to add the rest of her wardrobe, a pair of long black gloves. When she got back to the set I presented her with her prop, a black feather duster, and she promptly cracked up again.

Most pinup scenarios are completely over the top, but the situations are so ridiculous that your subjects truly get into the moment and deliver great performances. *Photo 5.22*

Green Screen for Pinups. I love using green screen for pinups. It's perfect for creating and inserting backgrounds that would be difficult or impossible to engineer in the studio.

The majority of 1950s pinups involved solid color backgrounds, possibly with some gradation. Some used a solid color shape. See chapter 7 for some of my favorite (read: easy) ways to create them.

For the first shot, I used two strip light softboxes to light the background. I kept the medium, 3x4-foot softbox above and the small, 2x3-foot one below my model. I added an additional softbox on a boom above her at camera right. This was powered $\frac{1}{3}$ stop above the main light and was meant to look like a splash of soft sunlight across her. This was a frequent trick of pinup painters, and it added a great deal of contour to the model's body. *Photo 5.23*

I knew the green in her vintage swimsuit would disappear as soon as I employed the AdvantEdge plug-in, but it's easy to bring it back with Photoshop's History Brush. The only hard part would be the very edges where the green of the suit met the background. The work would not be impressively difficult, but it would require a hard edge on the brush and a steady hand on the mouse.

The background was created by selecting a color off the suit that would fit the occasion, someone being photographed at a beach. The end result is a terrific example of a 1950s pinup, if I do say so myself. It has all the elements: a pretty girl, sexy clothing, a prop for humor, wonderful styling, and a great expression from the model. *Photo 5.24*

Above—Photo 5.23. *Right*—Photo 5.24.

The next one was a little tougher because the beach ball contained a lot of green. I would have been happier with one in a different color, but finding a beach ball in Minnesota for an October shoot wasn't going to happen. It was all but impossible to bring the color in the ball back with the History Brush without getting some of the green background behind the edge. Once I had the entire ball returned to its natural color, I used Photoshop's Elliptical Marquee to create a perfect circle the same size as the ball itself, moving it into position and erasing everything outside the circle that was not part of the shot.

The contact shadow had to be created because the green screen under her feet was lit brightly enough to mostly disappear. I also added a slight vignette to the corners. *Photo 5.25*

For the final shot of this series I had only to lower the lights toward the floor, metering and adjusting them to get the same ratio as before.

In this case, the contact shadow was strong enough that it was retained by the plug-in. With the Ultimatte plug-in, if an object is, say, 50% transparent in real life (like a shadow), it will be retained that way but without any green, showing itself as a real, natural shadow against any background you or I create. If you look closely at the shadow, you'll see some of the cracks in the cement of my warehouse studio floor. *Photo 5.26*

Left—Photo 5.25. *Facing page*—Photo 5.26.

BARE-SHOULDER PORTRAITS

There was certainly a great deal of drama in '50s images, too. What I've come to refer to as a "bare-shoulder portrait" certainly didn't originate in the '50s; it had been around for a long time, but the creative world seemed to embrace it as an alternative to the drape of the '40s.

These days, it won't take much more than asking your model to bring a tube top to the shoot. It's a simple yet extremely sexy approach that leaves much to the imagination.

View cameras were still in vogue in the '50s (they've never actually gone away, although images have to be created on film of all things) but were slowly losing ground to other formats.

The beauty of view cameras was that the plane of focus could be changed to selectively focus on certain areas. It's a look that's unattainable with the vast majority of digital equipment (unless you've got an extra $40,000 burning a hole in your pocket), but it's easy to create the look in Photoshop. See chapter 7 to learn how this is done.

SIMPLE GEAR, GREAT PHOTOS

If you were to go through all the reviews of my books on Amazon (there are ten before this book—it might take a while), you'd find a couple that say something like, "I could do exactly what he does if I had the equipment he uses." Truth is, you don't need to have the same gear that I do to get stellar results. It's how you make it work for you, understanding its limitations (my gear has those, too), and working within them that will make you a better photographer.

This image was made with a $12.00, 500-watt, industrial work light that you might buy at your local hardware store so you can see your living room walls as you repaint them. I modified it only slightly, drilling holes in the tubing so that I could mount an umbrella into it.

My model was positioned about 4 feet from the background. I wanted to be sure the background received enough light from the light spray beyond the umbrella itself (given the laws of physics, of course) so as to be recognizable as a painted drop and to keep enough light on it to show her form against it, no matter how deep in shadow. Unless you use it as a part of the composition or to make a point, tonal merger should be avoided.

Aside from the stand, the most expensive part of this lighting setup was the bracket that held the work light to the stand. It cost about $45.00.

Unless you know that you'll be converting these images to black & white, be sure to do a custom white balance for the light. At the very least, set the white balance preset to incandescent. *Photo 5.27*

This image was made with a $12.00, 500-watt, industrial work light.

COOKIES AND SNOOTS

I was pleased to make the acquaintance of a woman who occasionally impersonates Marilyn Monroe at convention booths or other functions. She was

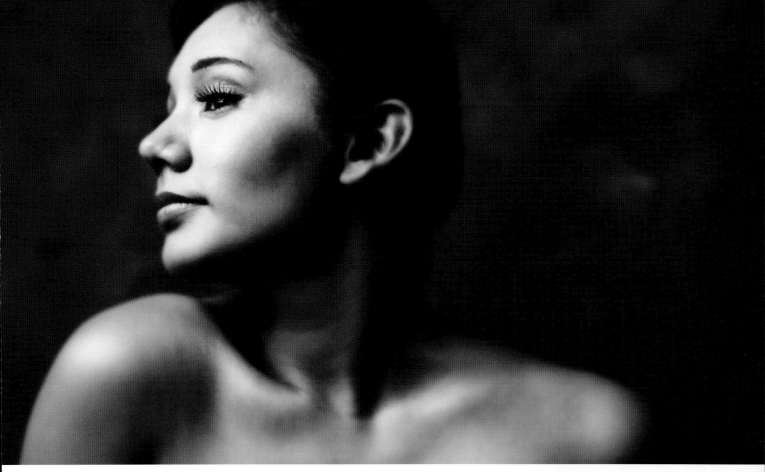

Above—Photo 5.27. *Right*—Photo 5.28.

great fun to work with and gave me several great performances over our few hours together.

Hollywood photographers frequently threw patterns on their backgrounds by pushing light through a device called a "cookie." These modifiers were often used to create the impression that the subjects might be someplace other than where they actually were.

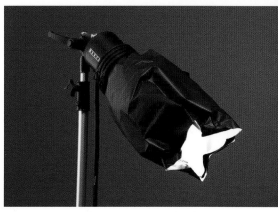

Another frequently used light modifier, especially with hot lights, is the "snoot." A snoot is essentially a tube that fits over the light. It is long enough to force the light into a tight pattern and acts much like a grid does on a strobe. Snoots do not have to be commercially manufactured items, you can easily make them yourself with a product called Cinefoil (go to www.rosco .com, select your country, and search for Cinefoil), a heavy-duty, matte black aluminum foil that can be manipulated into a variety of shapes. It can also be used to make an extremely lightweight flag that can block stray light from striking your lens. *Photo 5.28*

Prior to the model's arrival, I built a very simple cookie by attaching three strips of cardboard, horizontally, between two light stands. An additional vertical strip was attached in the middle. A bare tube strobe was placed about 4 feet from the pattern and angled to throw a believable but out-of-focus pattern on my white paper background. The light was blocked from hitting the model by a black bookend. An additional piece of 30x40-inch black foamcore was clamped to another stand and raised to block light from hitting the top of the background. *Photo 5.29*

Behind the black bookend, I placed a strobe with a beauty bowl and 25 degree grid. This is nothing new, as it's one of my favorite hair light combinations, but to soften the light further, I covered the dish with a diffusion sock, an elastic-rimmed piece of translucent cloth that's stretched over the bowl. The socks are somewhat expensive but are flimsy because the cloth is so thin. A usable but less elegant solution is to buy a piece of cloth at a fabric store, stretch it across the bowl and tape or clamp it in place. Be aware that you'll need to color check it before actually using it for a paying job, as it may look neutral but may skew the color. Obviously, anything that's off-color shouldn't be used, but you should be able to try many pieces of cloth for the cost of a single sock.

I wrapped two parabolic reflectors with Cinefoil, placing one where the main light would be, the other off to camera left, to add an accent to her side. *Diagram 5D*

With the model on the set, I turned on the main light and crumpled the Cinefoil into a shape I liked, an irregular circle that would illuminate her face, but allow the light to fall off over distance. The second light's snoot was bent into a tighter shape and aimed to accent the model's bust, with a little extra light across her camera-left arm. You can see how tightly controllable a modifier like this can be. Both of the accessory lights were powered $^1/_3$ stop over the main, but the cookie light was powered a full stop over the main because I wanted a pure-white background with a hint of window shape. The end result? A very successful image. *Photo 5.30*

> To soften the light further, I covered the dish with a diffusion sock.

Left—Photo 5.29.

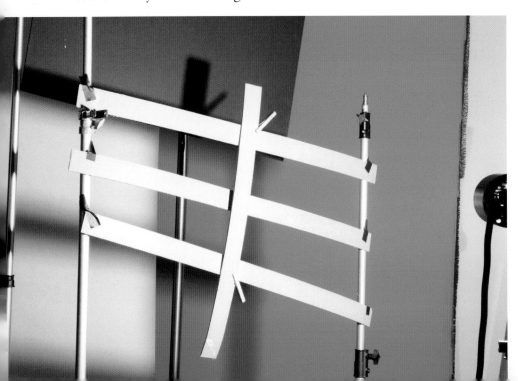

Above—Diagram 5D. *Right*—Photo 5.30.

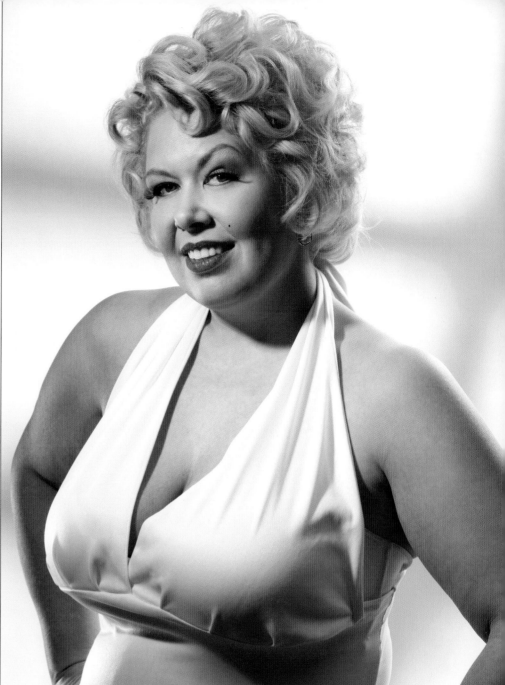

In my studio, everything exists to be anything I want it to be. Redressing a couch by throwing a piece of cloth over it and changing the position of a cushion produced a look reminiscent of the once-popular fainting couch, a prop frequently used in retro work.

For the next shot, I was looking to produce a glamorous, softly lit portrait using one of the Cinefoil snoots as a subtle accent. I squeezed the top and bottom of the snoot almost together, leaving an irregular slit for the light to pass through. This light would be aimed across the background, just above the couch. *Photo 5.31*

My main light was a strobe and umbrella, mounted on a boom. What made it different from most uses of such gear is that it was placed very low and very close to the model. It was so low that I would have to shoot on my

Top—Photo 5.31. *Bottom*—Photo 5.32.

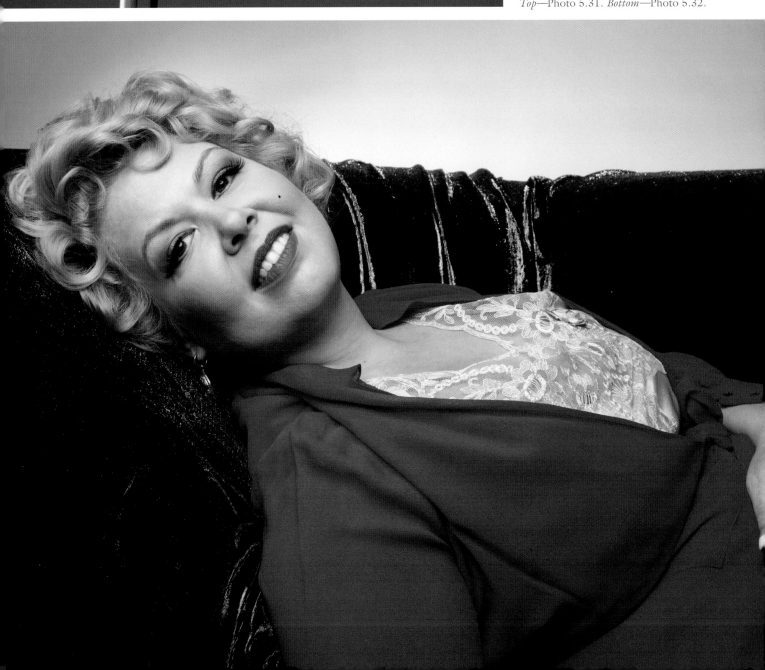

knees to get under it. I positioned it this way for two reasons: Being so close, the light would be broad and soft. Also (this is still part of reason one), the cloth covering the couch has a shiny aspect that only reacts to reflective light. In other words, a ring light would probably cause 90 percent of the fabric to return a shine. My second reason for such placement was that the light would fall off rapidly. The couch was placed only about 5 feet from the background. I wanted the background to be gray enough to show the subtle highlight. Placing the light close to the model guaranteed a rapid falloff.

Once the model was in place it took only a few minutes and a few test shots to refine the position of the main light. This model gave me a great performance, even though her position was mildly uncomfortable, given that both seat cushions had been removed to get the correct position for her body. *Photo 5.32*

MIRRORS FOR RETRO PORTRAITS

I have always been fascinated with retro Hollywood's use of mirrors for photographs of its stars. The fact that they make for an interesting prop is one thing, but (to me) they become a symbol of the narcissism that's typical of so many people who have attained stardom.

Still, when I'm contracted to produce a shoot, it's my job to turn my clients into movie stars, and I'll use every trick in the book. Come to think of it, this *is* the book.

Creating a "bed" is easy. Just throw a cushion of some sort on the floor (I usually use a sleeping bag because it doesn't show the contour of an inflatable mattress) so the model is not trying to pose on unyielding wood or concrete. If you're working with a mirror, you'll need to choose your essential shooting position before you ask the model to come to the set. You'll want to make sure that the edges of the "bed" extend to the very edges of your frame. If you could see this set, you'd see that additional sheets were placed well beyond the cushion, away from and behind her. The last thing you want to see in your shot is a light stand in the mirror.

There were two lights in play for this shot. The main light was a Cinefoil-snooted strobe, placed on a boom and aimed into the mirror so that the light would bounce off the mirror and reflect into my subject's face. The boom was angled so the model would receive light with an attractive nose shadow. It's not tough to do, but it's also easy to create a bad shadow. The important face in a photo like this is the one in the reflection, so take a little time to make sure it's perfect.

The second light was a 2x3-foot softbox that had been set on the opposite side of the model and aimed into my white ceiling. It was powered to one stop under the main. Its only purpose was to throw a little soft fill into the shadow areas that we would see in the mirror's reflection. It would also provide a believable look behind the shadows, because the main light would fall off to dark very quickly. *Photo 5.33*

> The boom was angled so the model would receive light with an attractive nose shadow.

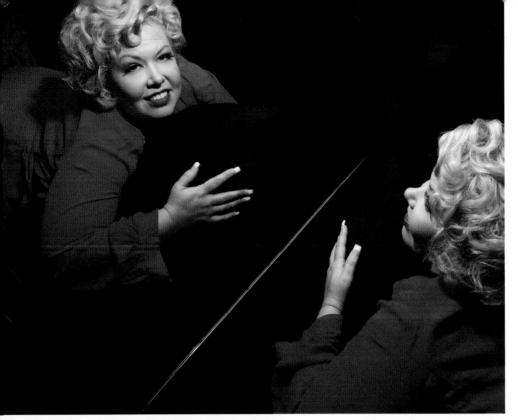

I wrote earlier of narcissism, self-adoration that borders on a personality disorder. Whether the stars represented were, indeed, narcissistic is a matter of debate, but they were often photographed in that manner. I've found it quite interesting that the subjects I've photographed with a mirror have really

enjoyed the experience. It's almost like revealing that they enjoy and are comfortable with themselves and are also comfortable revealing that to others. Just between us, when you build a set that involves a mirror, you're bound to get beautiful images.

I directed my model to "make love to yourself." She looked in the mirror, admired her hairstyle, wardrobe, makeup and, of course, herself, immersing herself into the shoot experience. While it wasn't the psychologically cathartic experience for the model that I've seen with other shoots, it didn't pound sand, either. *Photo 5.34*

THE SEX KITTEN

In the 1950s, the sex kitten look was a big hit, not just a buzz word. When working with a mirror, remember to try a few shots where the reflection is the key to the image. Note that the light on her physical face is not as nice as that on the reflection. Also note that her physical face is almost overlooked when viewing this image. *Photo 5.35*

Using a mirror is a technique that translates beautifully to contemporary boudoir photography, not just retro Hollywood. If you're interested in this genre, you can find more information about the techniques and the mind-set

Below—Photo 5.35.

behind it in *Christopher Grey's Lighting Techniques for Beauty and Glamour Photography,* a previously released book that was as much fun to produce as this one.

The only thing that was different for this shot is that I did not use the fill light to illuminate the edges. My crop was tight enough that I felt the tonal merger would actually contribute to the look of the shot. I was right. The sweep of the curved mirror behind her, combined with the black background, the dripping wardrobe, and dreamy look in her eyes combine to form an image that any guy is forced to look at. Most women, too, but for different reasons. *Photo 5.36*

MAD MEN

You will photograph far more women than men. Women enjoy the studio experience—the makeup and hair, the attention from the photographer—much more than men do. To most men, being photographed is reserved for family or business portraits. That said, when you photograph an attractive couple for an engagement or other photo, you might suggest that they make several hours available to be photographed as retro movie stars. When they experience it together, it's more fun for both of them, especially the guy. A bottle of wine and cold beer in the fridge might help, too.

In the '50s, suits changed from the stodgy, wide-lapelled and often double-breasted styles of the late '30s and '40s to sleek shapes with much narrower lapels that did a much better job of conforming to the man. Two buttons, placed low, allowed the viewer to see more of the necktie. The tie itself was thinner than in the previous decades, and longer (just a bit further than the top button when tied), with a new design palette. While not as garish as some '50s women's fashions, it was a great leap for men.

I began by mounting a 2x3-foot softbox on a boom. I wanted it relatively high, but close, to get an angled shadow that would be attractive to the subject and fall off quickly. I also brought in a white bookend for a little bounce into the shadows. Because of the angle and size of the softbox I knew I wouldn't get much, but that was fine with me. Men often look better with more shadow, especially in retro work.

Backgrounds for Hollywood portraits were often as dramatic as the clothing. For this series, I used nothing more than a strobe and parabolic reflector, but I began by mounting it on a short stand, raising it to the level of his back and aiming it straight and level to the background from a distance of 2 feet. Because he blocked most of the light as well as the strobe unit itself, the exposure was difficult to measure. I metered it for a two-stop overexposure above his shoulders, but it might be easier to look at it from the center of the hot spot on the background, a full four stops over the main. *Photo 5.37*

This scenario worked great when the strobe was moved in closer, to 12 inches from the background. It had to be powered down two stops because halving the distance meant doubling its strength, and, at that higher strength,

My crop was tight enough that I felt the tonal merger would actually contribute to the look of the shot.

Facing page—Photo 5.36.

it would have blown out more area behind the model. I wanted to keep it as consistent as possible. *Photo 5.38*

I've often been asked to include setup pictures of the studio in my books. I'm happy to do so when possible, and I've included a number in this book, but they are difficult for you to see and understand because there is usually no light from external sources falling upon them, and it's often tough to see what I've actually set up. The studio itself is not lit, only the set, and lighting it would dilute the effect of what I'm trying to show you. While this shot gives you an idea of what I've done, it doesn't show a whole lot. Personally, I think you'll get more out of the diagrams I include for the more difficult scenarios. They show you the basic positions of lights and modifiers, which you can play with to create images that reflect your personal style. I don't want you to copy me exactly, but I've stated my light positions and ratios and have no problem if you do. Beyond that, I do want you to exceed what I've done, if only because this kind of portraiture is a very fun and very creative part of the job. *Photo 5.39*

Facing page—Photo 5.37. *Left*—Photo 5.38. *Right*—Photo 5.39.

CHAPTER SIX

1960s—The Soaring Sixties

The 1960s were aptly termed the Soaring Sixties, as space exploration culminated with Apollo 11's successful landing and exploration of the moon in 1969 (or not, depending on your belief in conspiracy. If you're a conspiracy theorist, think of it by its other name, the Swinging Sixties).

Photographically, it was a very interesting time. The hippie movement, along with the so-called English Invasion as led by the Beatles, was just a taste of the major influences on fashion that would be presented over the decade. The Edwardian era, prevalent between 1910 and 1920, made a resurgence, producing clothing designed with extended collars and puffy sleeve fashions, updated for the moment and not just aimed at women. I wish I still owned my favorite Edwardian shirt. I wouldn't ever wear it again, but it would have been a great piece of wardrobe for this book.

The 1960s saw the greatest melding of image styles in the history of photography. That's my opinion, of course, but mainstream photographers who'd purchased 35mm cameras in the '50s were now buying medium format gear as well. Film and processing techniques, along with professional deadlines, were rapidly making the tedium of 8x10, even 4x5, view camera photography obsolete. Sound familiar? 35mm and medium format film and cameras, along with their requisite darkroom regimen, fell prey to digital technology in just the last decade. Success in the business of photography has always been an "adapt or die" philosophy.

Lighting in the '60s was, again in my opinion, a rehashing of previous styles, but with a few notable exceptions. We won't spend too much time in this decade, although it was very colorful. My intent is to examine and re-create a few shots and techniques that you will find useful to have in your visual vocabulary.

> The 1960s saw the greatest meld of image styles in the history of photography.

FRAMING THE SUBJECT

The first technique we will look at is the use of curtains to frame a subject. I first saw this approach used on a picture of Grace Kelly, but those curtains were white. It was quite lovely for her, with her blond hair and all, but I thought it would be substantially more dramatic with black curtains and a woman who looked more like a young Elizabeth Taylor. I'm all about drama

and will scour the earth (or at least a radius of 10 miles around the studio) for an appropriate wardrobe once I have an idea for a shot.

I was fortunate to find a vintage '60s dress that had a skirt lining similar to a seamless paper background that had languished in the Closet of Forgotten Backdrops for several years. Although my business is now more portrait oriented than its previous incarnation as a commercial advertising studio, most of the commercial work I've done has utilized white, black, or gray backgrounds. White is the most popular option because the look is clean and has always been contemporary. This was a background that had been purchased for a specific need, was almost complete, and (pack rats that we photographers are) should not have been thrown out just for the 6 square inches of floor space that could be gained. Come to think of it, I could gain about 15 square feet if I got rid of other old backgrounds. The rub is I'd have to replace them, one by one, if I had a need for them. Better to wait for retirement and sell them at $5.00 a piece, letting that almost complete roll of robin's egg blue become someone else's white elephant.

I used two black bedsheets, steamed and pressed as perfectly as possible and hung from a boom arm. I used a simple stationary clip to hold the two together, clamped just below the frame line. This allowed her to pull the two sides apart while retaining the triangular shape, a masterful and inexpensive solution to creating a beautiful composition.

My light came from only two sources. The main was a beauty bowl, without a grid, on a boom and above camera. The second was a strip light softbox set on the floor and angled up slightly to get a better spread of light. As I said, the color of the background was close in color to the fabric lining the inside of the model's skirt. It was a matter of finding the point where I felt the two tones would have equal visual weight, just below the model's armpits in this case. I know it sounds a bit crass, but "just below the model's armpits" is exactly where the point of equal exposure needs to be for this shot. Sometimes things need to be put bluntly to get the point across.

My first shot had my model opening the "curtains" just above the clip. It became a beautiful shot framed in a terrific triangular shape between the two pieces of cloth. *Photo 6.1*

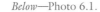

Below—Photo 6.1.

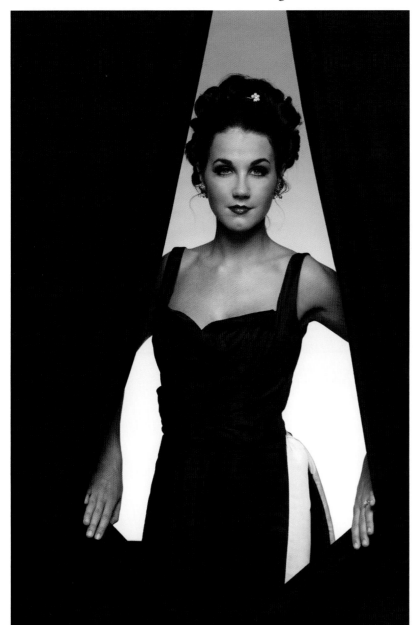

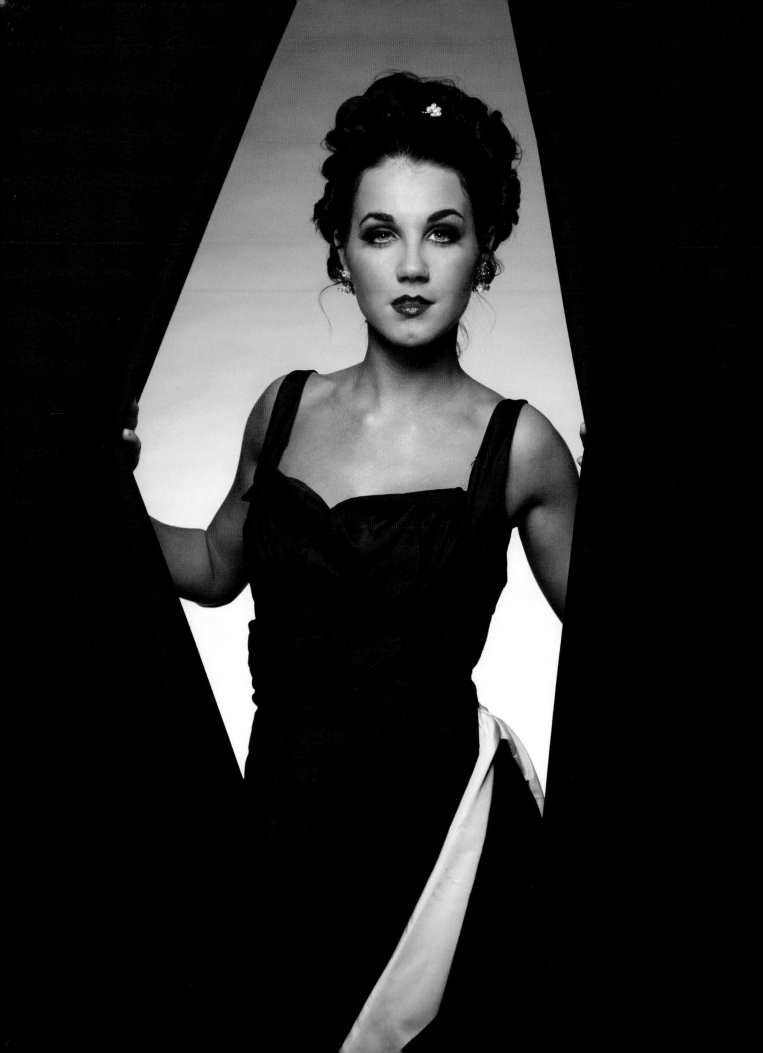

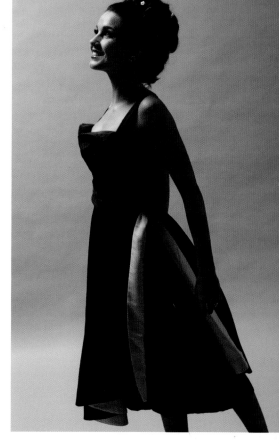

Facing page—Photo 6.2.
Right—Photo 6.3.

A second image had the subject opening the curtain at the middle, creating a diamond-shaped opening. It's just as effective, but in a slightly softer way because it looks like more of a curtain opening than a tear between two pieces of cloth. It's your call, but I think both versions of this scenario need to be presented to your client. There are many other approaches you might wish to try with this scenario as well, most dealing with how your model opens the curtains and the position of her body as she does so, but I'll leave those up to you. There are only so many pages I can fit into this book. *Photo 6.2*

BACKGROUND FLAWS AS ELEMENTS

There was an interesting twist to fashion photography in the '60s. Photographers sometimes avoided the look of a smooth paper background by lighting it in such a way that the normal surface, which is not completely smooth, showed its lumps and bumps. The influential fashion photographers also racked their main lights very high and asked their models to either look up toward them or hold their heads low and into shadow (not a great look for a paying retro client in my opinion).

> The influential fashion photographers racked their main lights very high.

I used a medium softbox, but you can use almost any light modifier for a shoot like this. The trick is to place it close to the background so the light will hit and shadow the texture of the paper. I also incorporated a white bookend behind the model to open the shadows on her back. Her backside would have been almost completely black without it. *Photo 6.3*

GOTTA GO-GO

No representation of the '60s would be complete without a shot of a go-go dancer.

Each year, I frequent Halloween "superstores" to see what's new in costumes. One can often find a number of vintage styles, sewn to fit almost everyone, for much less than an actual vintage outfit. My go-go outfit was no exception, costing about $30, boots included. At that price, it's cheaper to buy it than to rent it (assuming you can even find such a thing). I've purchased other items, such as capes, that I use when shooting specific concepts like goth.

I used two large, 4x6-foot softboxes, positioned to the left of the camera. The one farthest from the camera was set vertically to light the subject evenly

from top to bottom. The second was set horizontally, butting up to the first and extending just over the edge of my frame. Both were powered, individually, to the same f/stop, then metered together to get the final, working aperture. Note how, with this setup, the shadows are almost nonexistent because the light source is huge and wide. You can use smaller softboxes, even umbrellas, but the ultimate look of the light will be different. *Photo 6.4*

Occasionally, and when a subject has a great sense of humor, I'll use one of these costumes to create a visual cartoon. My model for the next shot is one of my favorite models ever, Denise Armstead, and I've been photographing

Left—Photo 6.4.

Note how, with this setup, the shadows are almost nonexistent because the light source is huge and wide.

Photo 6.5—Every so often, retired go-go dancer Alice "Micki" McAndrew feels the need to don the ol' uniform for a few minutes of cardio. She sold her white boots at a garage sale in 1972. She regrets that.

her for over twenty-five years. She's one of the very few I'll ever get to know who'll lay her psyche on the line whenever we shoot. She can assume any persona—a skill that's a godsend for a guy like me.

She stopped by one day to chat and have a glass of wine, saw the go-go costume hanging on the rack and loved it. My advice? "Try it on." She did, and it was a perfect fit. She's a performer, a professional dancer and choreographer, and wanted to own the costume. I said she could, but only if we created a shot with it that was truly "over the top."

Needless to say, free spirit that she is, she was on board immediately.

My initial thought was to create a 1960s image that was both humorous and somewhat poignant, an expression of aging and of trying to hold on to youth, laced with fun and a complete disregard for the effects of the years that will, eventually, plague us all.

She has a more down-to-earth, "whatever works" wardrobe than any woman I've ever known. I'm sure I could find such props for a model, but I merely had to ask her to bring odd socks and work boots, counterparts to the go-go outfit. She naturally wears her hair in a loose, retro style and rarely uses makeup on her own. I used the same lighting as I did with the previous go-go dancer, and the result, with or without the caption, is hilarious. *Photo 6.5*

When you shoot with someone and you both sense a connection, make the most of it. While you may document many moments in your friend's life, the ultimate benefit of such a relationship is that your subject will let you into his or her soul, a place most photographers will never truly see. I'm serious about this. I have several such friends that I've photographed over decades, one of whom I photographed throughout her first pregnancy and later in delivery. Eighteen years later, I shot her first son's graduation photos. These people trust me, and they will trust you if your heart's in the right place. My mission with them is to document their lives while they produce art for me (while adding to my bottom line, of course). It's a great trade, fun to do, and I'm honored by their trust.

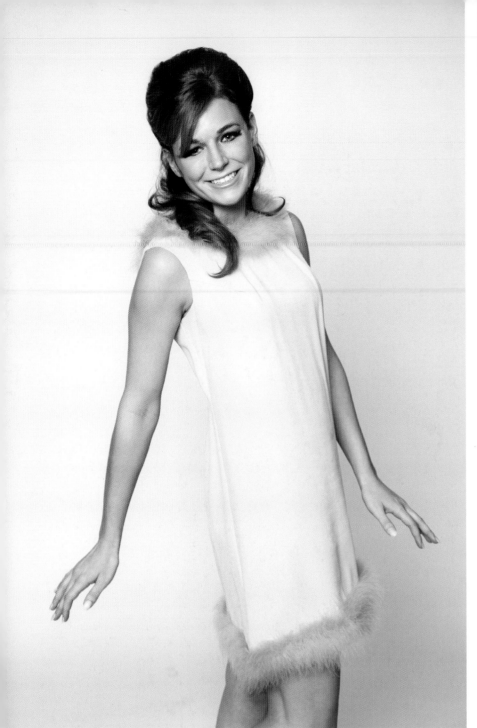

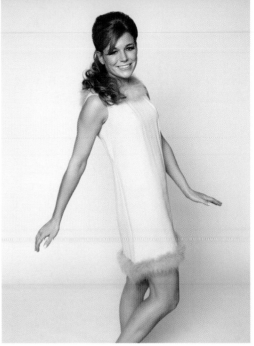

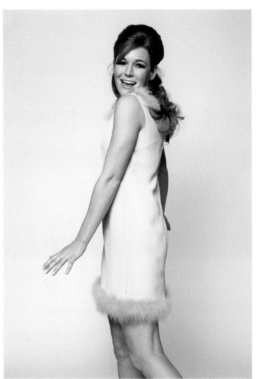

1960s Fashion

The '60s, at least in terms of fashion, married the flamboyance of the '50s to the new era of feminism and miniskirts. Along with the English influence of the Mods and the Rockers, fashion would never be the same.

While it is definitely possible to acquire or rent fashions from after 1900, it's much easier to find and recognize clothing from the '50s or later. At a recent estate sale, I found a wonderful pink A-line dress, with real marabou feathers. It was in perfect condition and cost a fraction of its original price.

I set out to do a typical '60s fashion shot. Many of those were shot on white backgrounds and with only one light. I needed to use the principle of

Left—Photo 6.6. *Top right*—Photo 6.7. *Bottom right*—Photo 6.8.

"depth of light," a corollary of the Inverse Square Law that states that the farther the source light is from the subject, the longer the distance—front to back—that is equally powered. I've written about this in great detail in other books, tomes I think you really need in your library. Hey, I like to go on vacation, too!

I set my main light, a strobe with a large, 4x6-foot softbox, on a stand approximately 12 feet from where my model would be standing, about 6 feet from the white paper background. Because of how light works as it falls off from its source, I knew the 6-foot difference between the model and the background would result in just a one-stop difference between the two, turning white paper into a light gray—perfect for this shot. This was the only light in play for this shot. Note that the single light produced a light shadow. Fashion photographers of that era rarely cared if there were shadows cast on the background, as long as they were soft and open. In many cases, the shadows cast by that era's lighting were actually harder.

Whenever you do a shoot that demands movement, your best bet is to overshoot, making many more exposures than you think are necessary. It will take you a little longer to edit, but I'm talking only minutes. The fact that you can shoot hundreds of frames and not have to pay for film processing is crucial to the success of any moving pose. When you do that, the possibility of finding several shots that are outstanding, as opposed to a few that are okay but not quite there, is seriously decreased. Edit time (not RAW file process time) should not be considered a drawback when shooting anything that moves. If you're shooting with a zoom, be sure to vary the focal length as necessary. Any one of these images is killer. *Photos 6.6, 6.7, and 6.8*

STREET PHOTOGRAPHY

In the 1960s, street photography, also known as informal portraiture (and a slew of other names) was extremely popular. It was basically a simple way to record real people against a neutral background. Posing was also extremely simple. People, no matter who they were, what they did, or how they looked, were directed to a mark on the floor and told to look at the camera. As I understand it, most photographers made very few frames of each subject, yet the images have a haunting, look-into-your-soul quality that other forms of portraiture rarely achieve.

The vast majority of these images were shot on black & white film—usually large format, because it revealed every detail, beautiful or flawed, that the subject presented to the camera. Lighting was very flat and there was no retouching except for dust spots. The idea was to show people as they really are.

Not only did I want to illustrate this form of imagery—it's still a valid form of portraiture—but I wanted you to see what it looked like as a vintage fashion lighting scenario, something that was frequently done at the time because the concept was so popular.

> Whenever you do a shoot that demands movement, your best bet is to overshoot.

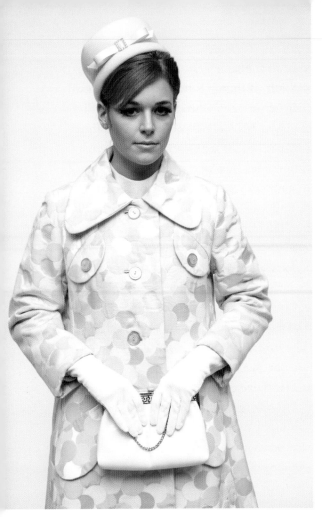

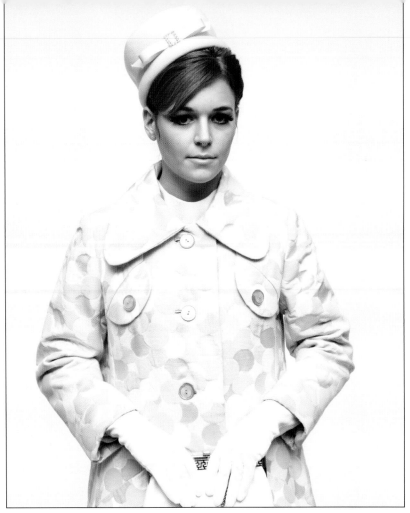

Left—Photo 6.9. *Right*—Photo 6.10.

My model went back to the hairdresser for a different 1960s style, something that a fashionable woman would have worn while shopping downtown or meeting a friend for lunch. Seriously. In the early '60s most women wouldn't be caught dead wearing less than this to go to the grocery store.

I began with a street photography look, and I placed a large, 4x6-foot softbox about 10 feet from where the model would be standing and aimed it at the ceiling. No direct light from the box was allowed to fall on her. I performed a custom white balance to negate any goofy colors that might reflect on the model from the ceiling or walls. If you know for certain that you're going to convert these to black & white, this step is not necessary. I think you should do it just to have the most flexibility with your images. I also think you'll agree that the 8x10 crop on the converted black & white is much more powerful, certainly more vintage, than the color shot. *Photos 6.9 and 6.10*

This outfit was just too cool to stop here, and I wanted to do a typical fashion shot using the same lighting. I put the large softbox back in its first position, aiming it once again toward the model. I wanted to eliminate even more of her side shadow than in her first example, so I butted up a medium, 3x4-foot softbox to the 4x6-foot softbox and formed a rough arc of light over the model. My plan was to shoot from under the middle of the arc, working under even light while creating an interesting catchlight in her eyes.

Both lights were separately powered to the same f/stop then metered together to get the working aperture. A rule of thumb is that if both are powered equally, the increase in power will be one stop when fired together.

I directed my model to act as though she was on a runway, a haute couture show. We shot well over a hundred frames, each in a position that one might see while viewing such a show. Such a request can be a stretch for a model, in this case a woman who had done only one runway fashion presentation. It's easy for anyone to feel foolish, intimidated, or shy when asked to do such a thing in a studio and in front of the photographer, makeup artist, and hairstylist. It's up to you to practice and refine your banter with each model who stands before your camera. The best advice I can give anyone who has not photographed as many people as I have is to pre-visualize your shot and rough-in the lighting. As you do so, think about how you wish your model to portray his or herself. Be confident when giving direction, but don't be afraid to gently ask the model to change a pose or attitude. I say *gently* because most of the people you will photograph are not and will never be "models" in the true sense, although you must be succint, even blunt, with your direction. They come to you because they want a look that you can provide, and provide well—and they are willing to pay for it. Practice for free on friends and family before you advertise this service. *Photos 6.11, 6.12, and 6.13*

Top left—Photo 6.11. *Bottom left*—Photo 6.12. *Bottom right*—Photo 6.13.

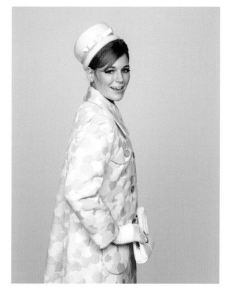

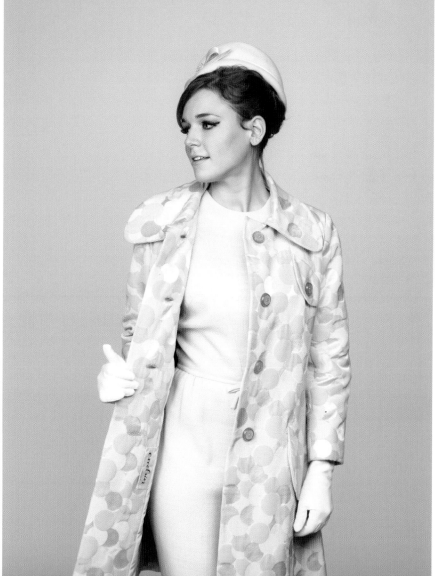

Tight Crop, Colored Gels

While there were many improvements on existing lighting scenarios in the '60s, one of the most important was the use of a tight crop. With view cameras, such a crop was possible, but at the cost of "bellows factor." As the bellows (the flexible, folding light tent between the front and rear standards) was extended, the amount of light reaching the film plane had to be increased by opening the aperture or decreasing the shutter speed. It's the Inverse Square Law again, because light will fall off through a lens in much the same way as from a

Above—Photo 6.14.

light. There is a somewhat complicated formula for getting correct exposure, but I won't bore you with it because I'm not sure I remember it. The point is that light meters and fixed aperture lenses made the bellows formula mostly obsolete. In other words, if you were working in 35mm with an f/4 lens, you could meter at f/4 (or any other aperture) as close as your lens would focus and still get a perfect exposure at f/4. This feature opened up a whole new world of portraiture.

Better film and faster lenses made tightly cropped, short focus images a viable commodity as publicity material. Many starlets, as well as seasoned stars, were photographed in this manner.

You can use colored gels to change the white balance of the light that falls on your subject. You can also use the same gels to selectively change the color temperature of light that may fall only upon certain parts of the shot.

There are gels that will change a daylight balance, approximately 5200–5500K, in steps, down to 3400K, the color temperature of incandescent light, called CTO (Color Temperature Orange). There are corresponding gels that will raise the color temperature of incandescent light to that of daylight, called CTB (Color Temperature Blue). Each of these is available in $\frac{1}{8}$-strength increments, so you can use whatever you might need to get the effect you want.

I wanted a slight hint of warm light to cross my model's shoulder and cheek, so I first taped a full sheet, about 24x30 inches, of $\frac{1}{8}$ strength CTO to the front of a 2x3-foot softbox. In the center of this gel, I taped a piece of $\frac{1}{2}$ CTO that was about $\frac{2}{3}$ the size of the other. This would give me the effect I wanted, a slightly warm look that was not too strong overall but strongest in the center of the spread. This light was set quite close to the model, about 3 feet away from her shoulder, and was flagged off from striking the lens by placing a black bookend between the light and what would be my position. *Photo 6.14*

My main light was a beauty bowl, fitted with both a 25 degree grid and diffusion sock. It was also placed within 3 feet of the model, as I wanted minimal influence from it to the background. We shot a number of exposures. I gave the model, as I frequently do, license to move as she wished. When someone is on your wavelength, you don't want to ruin the moment. Although any position looked good, I could see that the best shots happened when she turned her head to the left of the camera and laid her head on her gloved arms. I let her get through a few dozen exposures so she could get accustomed to the somewhat uncomfortable position before requesting that she just lean in my preferred position, and the results are beautiful, intriguing, and relaxed. The following images are just a few of the great shots I got from this scenario. *Photos 6.15, 6.16, and 6.17*

One thing you should remember when working with a crop that's this tight is that you'll need to refocus often, after every shot if you or your model is moving. The preferred place to focus is on the eye nearer the camera.

Below—Photo 6.15.

Top—Photo 6.16. *Bottom*—Photo 6.17.

FINAL TOUCHES

CONVERSION TO BLACK & WHITE

When I made the jump to digital I happily gave up my darkroom as well. It's not that I didn't enjoy it—I really did—but Photoshop easily took the place of stinky chemistry and the orange safelight. Being able to make minor changes in real time and without test prints was a miracle.

After the novelty wore off, I began to miss some of the things I used to routinely do in the darkroom. Manipulating contrast and grain through processing tricks to create stellar black & white prints was just one of them. In time I figured out how to re-create many of my favorite film/developer combinations in Photoshop but, frankly, it was a bit tedious. I know that sounds silly, given the immediacy of digital manipulation, but it took time to get just the right Channel Mixer combination as well as a perfect grain structure.

Still, here are some steps (starting points, really) for color to black & white conversion, using one of the shots from the 1930s chapter.

1. With the image open on your desktop, select Image>Adjustments>Channel Mixer. *Photo 7.1*

Right—Photo 7.1.

2. When the control panel comes up, select Monochrome at the bottom of the box. If this is your first time using Channel Mixer, or perhaps if you're using a version older than CS4, the red Source Channel may be at 100% with 0% showing in the Green and Blue channels. The trick here is to move the three sliders to percentages that will create a harmonious blend of gray tones. My experience has been that the red channel almost always gets the highest percentage, followed by green and blue, but you may find a different combination that works better for your images.

Use my example settings as your point of departure. If you like what you see, click OK. If not, continue to adjust the sliders. Note that the percentage total of the three sliders should equal 100. Your image will be converted to an RGB grayscale image. In other words, it will have color values that a photo lab print processor or inkjet printer can interpret into gray tones. *Photos 7.2 and 7.3 (before and after illustrations)*

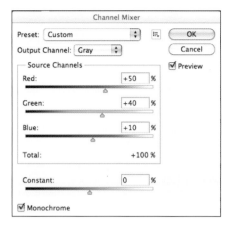

Above—Photo 7.2. *Below*—Photo 7.3 (before and after illustrations).

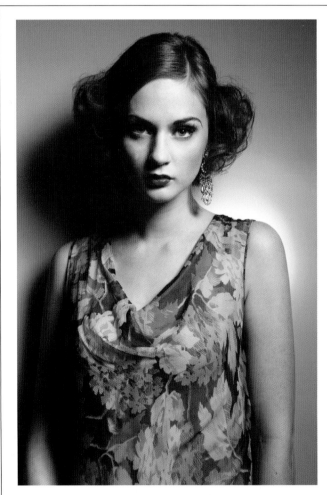
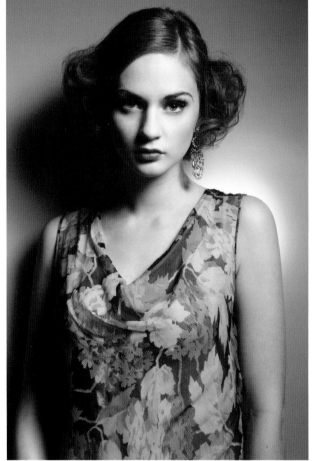

If you'd like even more control, and your version of Photoshop supports it, use Image>Adjustments>Black and White. You will be able to tweak the red, green, and blue channels as well as the yellow, cyan, and magenta channels. There are also a number of presets available to you, including a passable infrared, but watch carefully for banding. I'd suggest you use Image>Mode and change the image to 16 bits before doing anything, but be sure to change it back to 8 bits before trying to save it as a JPEG.

Either of these options is preferable to a simple conversion to grayscale, as this will strip out all color information without allowing you to make any decisions as to what tones are most important. If you go to Image>Adjustments>Black and White and select Discard, that's exactly what will happen. *Photo 7.4*

Adding a Grain Structure

After you make the conversion, you may want to add grain, a component of film that often defined its look. Lower ISO films developed in fine-grain developers might show a grain pattern that was difficult to discern. Higher ISO films, especially when push-processed to be even higher ISO, typically showed a much more coarse grain pattern.

Most retro portraits, Hollywood or not, were made with view cameras using 4x5, 8x10, or, at least in the case of Hurrell, 11x14 film. Grain would be mildly apparent in images made from 4x5 negative film, while non-existent in contact prints made with 8x10 and 11x14 film.

With the introduction of the technically excellent, medium format Hasselblad camera in the late 1940s, roll film cameras (the 'blad used 120mm film to produce $2^1/_4$x$2^1/_4$ inch, or 6x6 centimeter, images) began their rise to prominence as cameras of choice for photojournalists and portrait photographers alike. 35mm film, introduced around 1934, would not see much

professional portrait use until the 1960s, although many amateurs and some semi-pros embraced it in the '50s, especially for beauty and glamour imagery.

Let's take an image from the 1950s chapter and give it the look of 1950s black & white, 35mm film. *Photo 7.5*

Make the desired conversion to black & white, just don't use Grayscale. Duplicate the layer in Photoshop.

Go to Filter>Texture>Grain and select Grain Type>Regular. The default is 40 for Intensity and 50 for contrast, and this is a good place to start. Click OK. *Photo 7.6*

Photoshop's grain is a mix of RGB dots that doesn't look authentic when working with black & white images. I change the blending mode of this layer to Luminosity, effectively rendering RGB grain as a simple shadow of itself. *Photo 7.7*

*Left—*Photo 7.5. *Top right—*Photo 7.6. *Bottom right—*Photo 7.7.

Right—Photo 7.8.

Reduce the opacity level of the Luminosity layer to tone down the grain. For a shot like this I would reduce it to about 60%, but that's just a personal feeling based on thousands of rolls of low ISO, 35mm film shot over the years. Your tastes may be different. What works for you is fine with me. *Photo 7.8*

TONING

Colored toning, in which a fixed and washed print is immersed in at least one additional tray of solution, replaced silver grains with other chemicals. Toning is (or was) much more archival than standard fixing and washing, as silver tends to tarnish over time, no matter how well fixed and washed.

Toning is used in the digital environment not to increase an image's archival qualities—that's hard to do with something that only exists as binary numbers—but to re-create the look of images created in the past.

Sepia Toning. In its purest form, sepia is just a mix of red and yellow.

Begin with Image>Adjustments>Variations. Select Midtones. I usually like a moderate sepia tone, so I'll move the slider to Fine and select Yellow once, Red twice.

Note that you can dump the selection anytime by selecting Original. It's an easy way to start over. *Photos 7.9 and 7.10*

Selenium Toning. Selenium sulfite was very popular with portrait photographers, as the rich range of colors, from subtle blue to reddish brown, looked like a million bucks on prints made on double-weight matte paper.

This is a bit more complicated but still quite easy:

1. Go to Image>Adjustments> Variations. Set the slider at the second mark from the left.
2. Select Shadows and click Blue twice.
3. Select Midtones and click Red twice.
4. Select Highlights and click Yellow twice and Cyan once.
5. Click OK if you're happy. *Photo 7.11*

An Easier Way. There is a much easier way to do this that will give you many solid variations between retro film stock, grain structure, and toners. Alien Skin (www.alienskin.com) makes software called Exposure. At the time of this writing they had just introduced Version 3, and it's terrific. It's made my professional life (and many parts of this book) a whole lot easier.

Top left—Photo 7.9. *Top right*—Photo 7.10. *Bottom right*—Photo 7.11.

Black & White Film Stock

In the last few years before digital took hold, photographers had access to dozens of different film stocks, in black & white or color and from a number of manufacturers. Those of us who took the time to test at least some of them quickly found that each film had its own personality and subtle nuances, and that you could tailor your subject matter and film combination to maximize the look of your final product.

Software like this is perfect for retro photography and will give your images a look that doesn't seem "digital." *Photos 7.12 through 7.20*

And there are many more. They've also built in a selection of toners, from the popular to the esoteric. The best part is that you can charge extra for this service. Everyone knows this is a digital procedure, which is why the phrase "I use special software not created by Adobe" is important to remember.

In my never-ending search for things that will set my work apart from others, I often employ Exposure's color film settings for a little extra punch. Whether I use them as is or create a duplicate layer with an effect and blend the two together, the look is striking and difficult for my competition to duplicate, whether they use this software or not. All modesty aside, I think my lighting techniques are some of the best around. When you combine them with postprocessing of this caliber, your work will sing. My work sings arias.

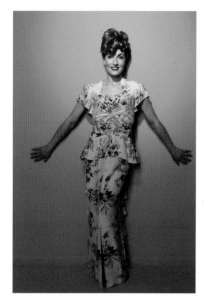

Photo 7.12—Typical digital file.

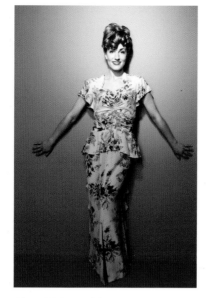

Photo 7.13—Kodak Technical Pan.

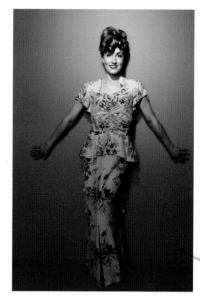

Photo 7.14—Kodak Tri-X, ISO 400.

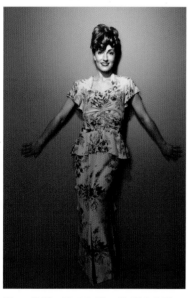

Photo 7.15—Kodak Plus-X, ISO 125.

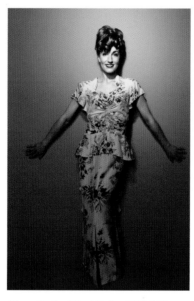

Photo 7.16—Ilford Delta, ISO 100.

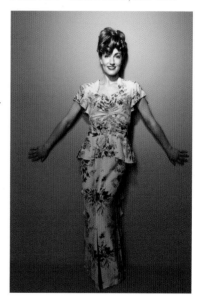

Photo 7.17—Agfa Scala, ISO 200.

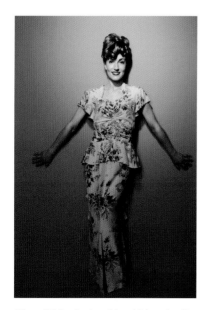

Photo 7.18—Sepia with mid-band split.

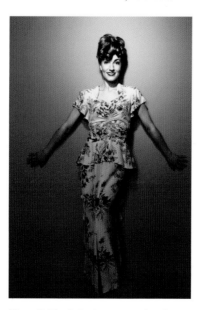

Photo 7.19—Selenium warm/cool.

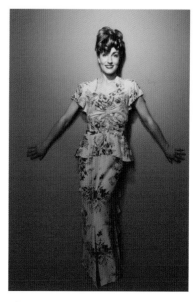

Photo 7.20—Polysulphide/gold split tone.

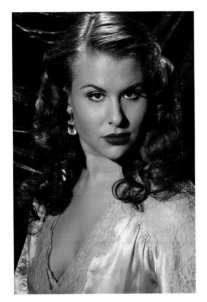

Photo 7.21—Typical digital file.

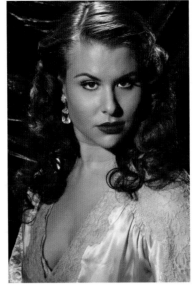

Photo 7.22—Agfachrome 1000rs.

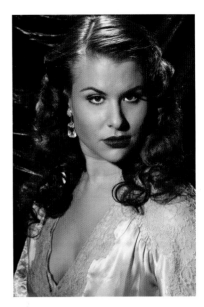

Photo 7.23—FujiPro 160S.

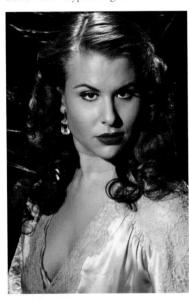

Photo 7.24—Kodak Portra 160VC.

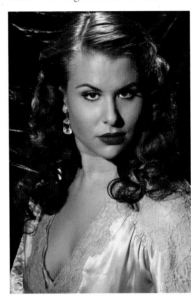

Photo 7.25—Fuji RSX II RF.

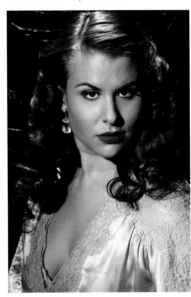

Photo 7.26—Fuji Velvia.

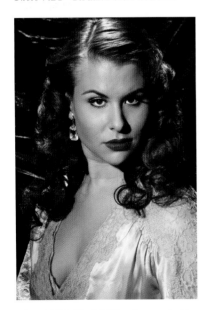

Photo 7.27—Kodak Ektachrome (mid-'70s).

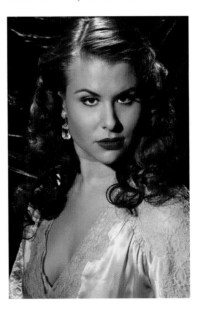

Photo 7.28—Kodachrome 25.

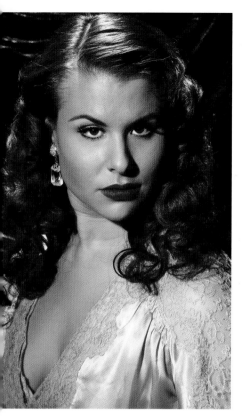

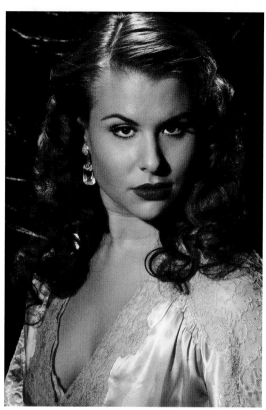

*Photo 7.29—*Fuji FP, 100C.

*Photo 7.30—*Polachrome.

*Photo 7.31—*Type 669, Creamy Blown Highlights.

Exposure also has several settings for professional Polaroid films, now long gone, as well as some of Fuji's. I remember that era like it was yesterday (and what a profit center Polaroid was for the studio!). Instead of checking an image on a tethered screen or the back of a camera, we'd shoot a Polaroid of the setup and each change the art director would order. Cha-ching! *Photos 7.21 through 7.28*

Exposure's Polaroid settings are very true to the films as I remember them. My favorite is Creamy Blown Highlights. If you ever shot Type 669 and got this effect, you know exactly what I'm talking about. *Photos 7.29 through 7.31*

One other consideration for this software—quite thoughtful, actually—is that you can go into the control panel and change any and every aspect of your final image: grain structure, saturation, everything.

VIEW CAMERA FOCUS

There are a few examples in the book indicating that selective focus is beneficial to many retro looks. As I mentioned earlier in this chapter, photographers, especially Hollywood types, used large format view cameras to create their iconic images.

A trait of view cameras is that the lens side, the front of the camera, can be moved and rotated separately from the film side, the back. These two planes, called "standards," were sometimes rotated in opposition to each other,

Left—Photo 7.32.

resulting in narrow areas of sharp focus in an otherwise out-of-focus environment. The results were beautiful, something traditional portrait photographers typically didn't do because it was difficult to set up as well as control. Bear in mind that a photographer could only view the subject through an open lens, upside down, against a ground glass screen, and with a black cloth over his or her head. It must have been torture for clients unaccustomed to holding absolutely still for photographs to wait while the photographer made adjustments. For Hollywood stars, though, it was all in a day's work.

Photoshop is the perfect tool for replicating this effect, provided you understand how layers and masks work. Most everyone does these days, but if you don't, you might want to learn. Layers and masks are valuable for all sorts of effects and tweaks.

My basic shot is one that's in the 1950s chapter, full of drama, great angle, and shot in color. My first step would be to convert it to black & white, and I'll use an Alien Skin Exposure 3 preset, Fuji Neopan 1600, a somewhat coarse setting, at least in terms of contrast and drama. In other words, perfect for what I have in mind. (You should know that this will look different from the shot in the other chapter, as I'm interpreting the image differently today than when I made the original.) *Photo 7.32*

1. The first thing you should do is determine which plane of the model's face you wish to remain in perfect focus. In this case, I think it should be a minor plane that extends down from her eyebrow, across the left lobe of her nose to her lip. I'll keep just a little of her hair in focus as well, since it's almost on the same plane, but I want everything else to fall out of focus with varying degrees of strength.
2. Duplicate the layer. With this first layer selected, select Filter>Blur> Gaussian Blur and set a value of 2 pixels. Create a white mask and paint

Left—Photo 7.33. *Center*—Photo 7.34.
Right—Photo 7.35.

Right—Photo 7.36.

a narrow path through that plane with a black, soft-edged brush at 100% (use a harder edge for detail at the edges). This will guarantee that this area will remain perfectly sharp through all remaining steps. The mask for this first layer will be quite minor. *Photo 7.33*

3. Duplicate the layer and the mask. Go back to Gaussian Blur and change the setting to 5 pixels. Set the opacity of the brush to 50% and paint through more of the face and the parts of the model close to the area of perfect focus. *Photo 7.34*

4. Duplicate this new layer and mask. Set the Gaussian Blur amount to 10 and paint through the mask with the brush opacity at 20%. *Photo 7.35*

5. Duplicate the last layer one more time. Set the Gaussian Blur to 25 and click OK.

6. If you're happy with the result, select Layer>Flatten Image, then save the image. If not, you can revisit each mask and tweak the edges by either adding black to reveal more of the layer below to add sharpness or white to eliminate any part of the mask that you don't like. *Photo 7.36*

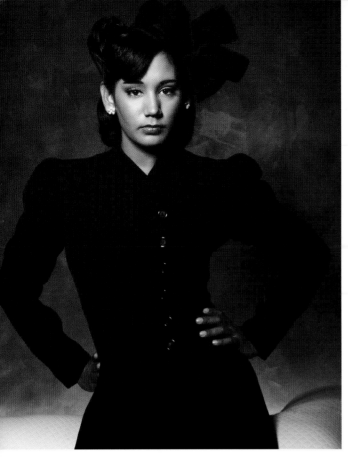
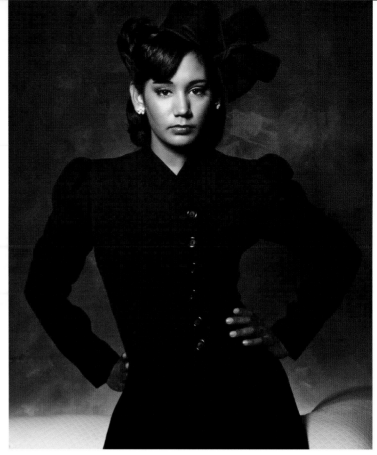

One more thing: when converting from color to black & white, dark or black clothing, hair, or props increase apparent density, lose detail, and become featureless blobs. Before conversion, you might wish to duplicate the layer, set the blending mode to Screen, and create a white mask. Paint through, at 20% opacity, to reveal the now lightened fabric. It's a cheat, but it's a good one. *Photos 7.37 and 7.38*

Left—Photo 7.37, straight conversion. *Right*—Photo 7.38, image after masking to retain detail.

Creating Backgrounds for Green Screen Pinups

Even though there is the impression of depth, with shadow and highlight, creating one of those nifty pinup backgrounds is quite easy with Photoshop. To illustrate how this effect is accomplished, I chose an image from chapter 5.

1. I began by choosing one color from the many choices available in the model's swimsuit, using the Eyedropper tool. That color became the Foreground color.

 Clicking on that color called up the Color Picker. For the moment, I simply noted the number of the color, ef995e in this case. I switched the Foreground and Background swatches and went back to the Color Picker by selecting the new Foreground color. I typed in the chosen background reference, ef995e, to be taken to that color. (You could choose a lighter or darker color; it's your call.) I chose bc6931, a darker, richer derivative of the original color.

2. On a new layer, I used the Elliptical Marquee to draw a perfect circle by holding down the Shift and Option keys. (I'm a Mac guy, and I'm not

Top—Photo 7.39. *Bottom*—Photo 7.40.

sure which keys to use on a PC, but if that's what you have, and you're proficient in Photoshop, it should be a no-brainer for you.) Once the circle was drawn, I used Select>Modify>Feather at 2 pixels and filled it with the Foreground color. The two-pixel Feather will create a soft edge. After you do this, do not deselect the circle.

3. From the Tool palette, I selected the Gradient tool then Radial Gradient. I created a blend of the two colors that followed the direction of the light used for the pinup itself. *Photo 7.39*

4. From the Tools palette, I selected the Burn tool. I set the Range to Midtones and the Exposure to 20%. I selected a large, 600-pixel brush, with the softest edge possible and darkened the form at the bottom to my liking. Next, I selected the Dodge tool and lightened the top, following the direction of the light with both tools. The result is a believable and dimensional background. I simply dragged it into my pinup (you can also drag your pinup onto it; also note that you can resize the image if necessary). Next, I saved the layered version as a PSD file, so it can be edited later if necessary. Finally, I deselected the border, flattened the image, and saved it (you can save it as a JPEG or TIFF for other uses). *Photo 7.40*

An Alternative Approach. Here's another way to produce the effect.

1. Another way to approach this would be to open the saved PSD image and create a new layer (not a duplicate layer). Working around the subject, use the Polygonal Lasso to create a shape. Select a color from within the image and fill the shape with it. *Photos 7.41 and 7.42*

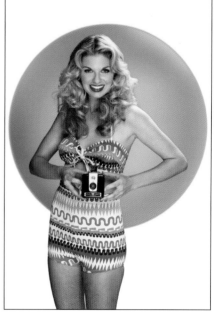

Left—Photo 7.41. *Right*—Photo 7.42.

2. Using the Burn and Dodge tools, darken areas you'd like darkened, then lighten some others. The result is a background that cannot be achieved by other means, and one that contemporizes the pinup look. *Photos 7.43 and 7.44*

We've been looking at a two-pixel edge for the last two examples. What would happen if we increased the amount of feathering? The larger the Feather Radius, the longer it takes for the fill color to reach maximum density. Changing to a larger radius will also cause any corners to soften and curve, something you can use to your advantage.

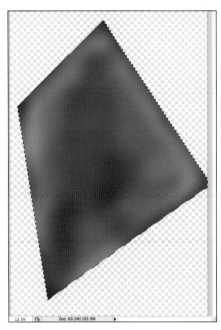

Left—Photo 7.43. *Right*—Photo 7.44.

It's a matter of aesthetics and your personal taste if you want a polygonal, elliptical, or circular shape. I'll use an elliptical shape for the next example, just for the sake of variety.

1. Working again with the PSD file, I created a new layer and selected a different color from the model's swimsuit. Using the Elliptical Marquee, I drew a shape behind her that I thought would work well. I set a Feather radius of 150 pixels and asked (demanded, actually, but that's just me) the machine to feather that edge before filling it with the selected color.

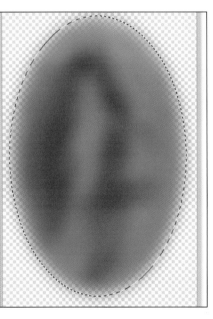

Left—Photo 7.45. *Right*—Photo 7.46.

2. With the subject layer in place and with the background layer selected, I did the dodge and burn dance that I did in the previous example, and to a beautiful end. Aside from the time it took to write about these examples, it took just a couple of minutes to try a number of variations to get the results I did. If you're new to this, it will take a little longer to get the hang of it but, trust me, it's a piece of cake once you do, and you'll be creating work your competitors will drool over when you're not looking. *Photos 7.45 and 7.46*

A Little More Eye Drama, Please

There will be times when you wish the makeup artist had put a little more mascara on the lower lids of a model. I know that for some decades the amount was minimal, but you will doubtless come up against situations where you don't think there's enough or that the makeup artist did the best-possible job working with thin lashes.

Here's a quick fix to add a little zip to lame lashes.

1. Open the image in Photoshop. *Photo 7.47*
2. Go to the Tools palette and select the Burn tool. Set the Range to Shadows and the exposure to 20%. Gently paint over the lower lashes with a small, soft-edged brush. You'll see them darken immediately. You can do the same to the upper lashes if you think it would be helpful. Stop (before it's too late)! *Photo 7.48*

Top—Photo 7.47. *Bottom*—Photo 7.48.

There are, of course, many more tricks you can apply to your images using Photoshop or other image-manipulation software. I would suggest you investigate all software, at least as many as seem popular, and learn to use what works for you and the look you're trying to achieve. As you've probably figured out by now, you can often combine an effect in one program with that in another, changing the look to something completely different from where you started. It doesn't matter how you get from point A to point B, from shoot to finished image, only that your end results make your clients happy and your competition weep.

Oil Tints

Prior to color film attaining popularity, one of the few ways to get a color photograph was to hand-tint a print with oil colors. It was a huge part of the industry, great for the bottom line. Even small portrait studios had people on staff or on call to do tinting, and they would work on prints with notes the photographer attached regarding hair and eye color as well as wardrobe colors. Those notes were subject to interpretation, of course, but good colorists were proficient at looking at a black & white print and selecting the appropriate tints.

The premise was simple; you'd find colors you liked and spread them over the print. If you went outside the lines, you would use another tube of stuff to remove the color. It was difficult to do complicated images, so the technique was mostly used for portraiture. It largely fell out of favor in the '70s but remains a viable technique for retro work.

Fortunately, Photoshop makes achieving this unique look rather easy. I'll use a shot from the '40s chapter to demonstrate. *Photo 7.49*

Left—Photo 7.49. *Right*—Photo 7.50.

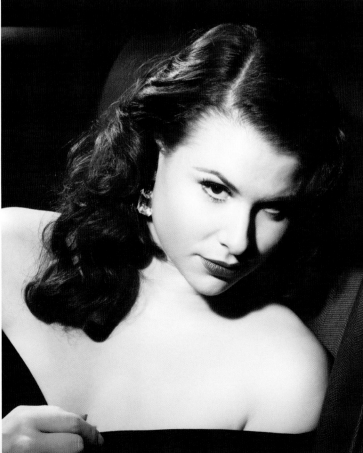

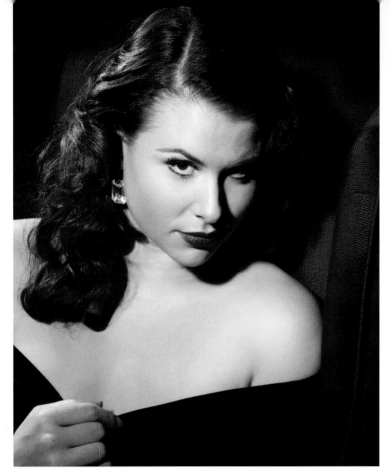
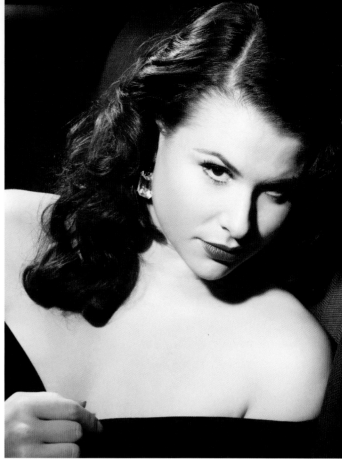

Left—Photo 7.51. *Right*—Photo 7.52.

The vast majority of oil tints were accomplished on sepia toned prints. It seemed the slight amount of toning in areas that were slightly less than white contributed to the look, in the whites of the eyes, for example. When a neutral print was used, those whites, which held no color, looked odd. *Photo 7.50*

It won't matter if you use my methods for sepia toning or those in the Alien Skin plug-in. The important thing to note is that each area of the portrait will be done on a separate layer in Photoshop, which will make it easier to make corrections on any area later.

1. Begin with a sepia or brown-toned image. You'll also want the original photo open so you can sample the correct colors for any part of the image.

 You'll want to start with the lowest feature on the person you'll be working on (i.e., the "lowest" part of the subject herself, her face). The background might be slightly different and not quite as important. For this shot, I'll start with her skin, which is below her hair. On a Mac, click CommandShiftN. I believe that, on a PC, the correct combination is ControlShiftN.

2. Go to the Eyedropper tool and select her skin color from the original image. Find a median color. Set the blending mode of the new layer to Color. With the Brush tool, paint the color, at 100% opacity, over the subject's skin. Note that facial makeup will color skin a bit differently, so save the face for the next layer. By itself, it looks pretty awful. *Photo 7.51*

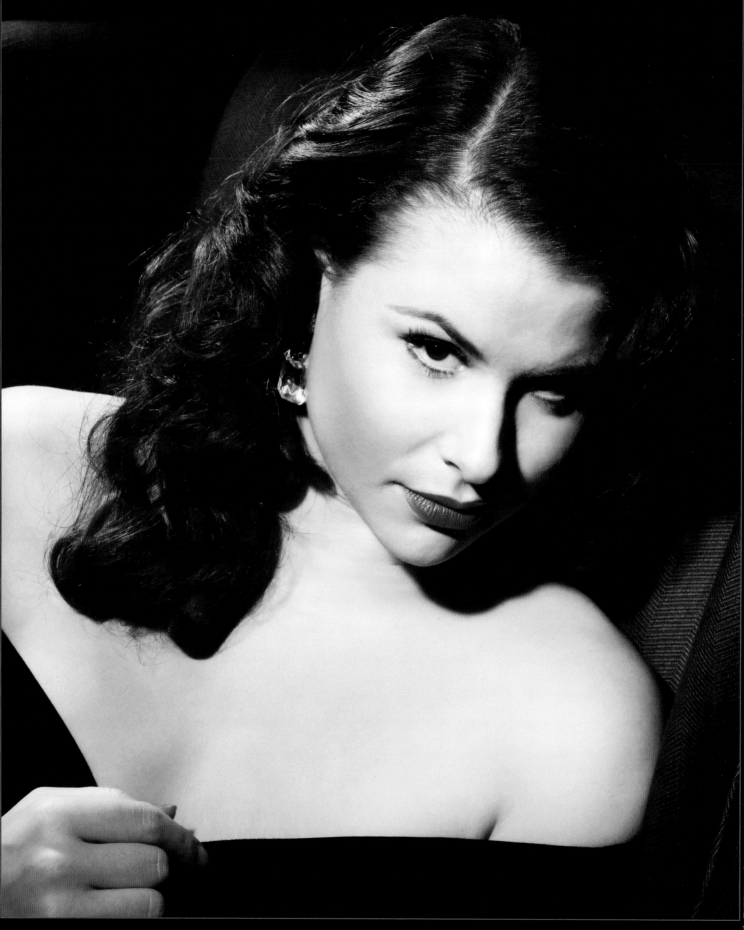

Facing page—Photo 7.53.

Your final result will be a terrific rendition of a retro, oil-tinted portrait.

save the face for the next layer. By itself, it looks pretty awful. *Photo 7.51*

3. Change the blending mode of the layer to Color. Use the Eraser tool or a mask to clean up the edges, setting the Opacity at 100% and the Hardness at 50%. This will give you a slightly soft edge to define the color range.

4. Select a median color from the face and create a new layer.

5. Paint over the face the same as before. Erase or mask any areas that intrude into others, especially the whites of the eyes or teeth. *Photo 7.52*

6. Create a new layer and sample a median color in her lipstick. Bring the oil tint image up to 200%, which will show you every pixel that has been coated with the stuff. Paint it on, being mindful of where the makeup artist placed it. Makeup artists will often reshape lips to be more faithful to the era of the photo. Again, set the blending mode to Color.

7. Do the same for the hair and eyes. Sample the colors and paint them in on individual layers, which gives you the opportunity to selectively remove any color that might intrude on another space. This is huge because it's so much easier than doing it via traditional methods. For eyes and hair, use the harder brush, as I did. When erasing around hair, use a brush with more softness, perhaps 20%, since the edges of a hairstyle are soft and hard to blend.

 Backgrounds were often left neutral. It's your call, but I think a sepia background (the chair in this shot) puts more emphasis on the model herself.

8. If you think your subject needs a bit more color and contouring, select those colors from the original and paint them in place. You might want to reduce the brush's Opacity setting to 20–30%, which will give you the opportunity to build the additional color, rather than just painting a swatch. Also, use the Burn tool to add a little density to just a few areas to give them depth and dimensionality. Your final result will be a terrific rendition of a retro, oil-tinted portrait. Print this out on your printer on top of a slightly textured, fine art paper, and you and your client will agree that the shot's a winner. *Photo 7.53*

AFTERWORD

This is a book project I hoped wouldn't end. Unfortunately, the publishing business runs on deadlines, so no matter how much fun I was having, well, it had to end sometime.

I hope this book is the start of a great adventure for you. I think you can see how valuable the creation of retro images can be, both to your clients and to your bottom line. Don't take my word for it, though. Practice these techniques on friends until you're satisfied you understand what I wrote about and use the best to produce killer samples for your portfolio and your studio. Make sure the friends you've used get prints as well, at least 8x10 inches, but bigger is better. They'll display them and talk about you. The best advertising is free advertising.

Speaking of free advertising, Jay Conrad Levinson (www.gmarketing.com) has written a number of terrific books on Guerrilla Marketing, the art of getting press and advertising for next to nothing. It doesn't matter if you're new to photography or a seasoned pro, if you've not read any of these, you should.

I enjoy hearing from my readers. If you have a spare moment, drop me a note and let me now what you thought of this book (Chris@Christopher Grey.com). Check out my somewhat sporadic blog, too (ChrisGreyLighting .com).

> I think you can see how valuable the creation of retro images can be, both to your clients and to your bottom line.

Master Lighting Guide
FOR PORTRAIT PHOTOGRAPHERS

Christopher Grey

Master traditional lighting styles and use creative modifications that will maximize your results. *$34.95 list, 8.5x11, 128p, 300 color photos, index, order no. 1778.*

CHRISTOPHER GREY'S
Studio Lighting Techniques for Photography

With these strategies—and some practice—you'll approach your sessions with confidence! *$34.95 list, 8.5x11, 128p, 320 color images, index, order no. 1892.*

CHRISTOPHER GREY'S
Advanced Lighting Techniques

Learn how to create twenty-five unique portrait lighting effects that other studios can't touch. Grey's popular, stylized effects are easy to replicate with this witty and highly informative guide. *$34.95 list, 8.5x11, 128p, 200 color images, 26 diagrams, index, order no. 1920.*

CHRISTOPHER GREY'S
Lighting Techniques for Beauty and Glamour Photography

Create evocative, detailed shots that emphasize your subject's beauty. Grey presents twenty-six varied approaches to classic, elegant, and edgy lighting. *$34.95 list, 8.5x11, 128p, 170 color images, 30 diagrams, index, order no. 1924.*

Master Posing Guide for Wedding Photographers

Bill Hurter

Learn to create images that make your clients look their very best while still reflecting the spontaneity and joy of the event. *$34.95 list, 8.5x11, 128p, 180 color images and diagrams, index, order no. 1881.*

ELLIE VAYO'S GUIDE TO
Boudoir Photography

Learn how to create flattering, sensual images that women will love as gifts or keepsakes. Covers everything you need to know—from getting clients in the door, to running a succesful session, to making a big sale. *$34.95 list, 8.5x11, 128p, 180 color images, index, order no. 1882.*

MASTER GUIDE FOR
Photographing High School Seniors

Dave, Jean, and J. D. Wacker

Learn how to stay at the top of the ever-changing senior portrait market with these techniques for success. *$34.95 list, 8.5x11, 128p, 270 color images, index, order no. 1883.*

Photographing Jewish Weddings

Stan Turkel

Learn the key elements of the Jewish wedding ceremony, terms you may encounter, and how to plan your schedule for flawless coverage of the event. *$39.95 list, 8.5x11, 128p, 170 color images, index, order no. 1884.*

Available Light
PHOTOGRAPHIC TECHNIQUES
FOR USING EXISTING LIGHT SOURCES

Don Marr

Find great light, modify not-so-great light, and harness the beauty of some unusual light sources in this step-by-step book. *$34.95 list, 8.5x11, 128p, 135 color images, index, order no. 1885.*

JEFF SMITH'S GUIDE TO
Head and Shoulders Portrait Photography

Make head and shoulders portraits a more creative and lucrative part of your business—whether in the studio or on location. *$34.95 list, 8.5x11, 128p, 200 color images, index, order no. 1886.*

THE PHOTOGRAPHER'S GUIDE TO MAKING MONEY
150 ideas for Cutting Costs and Boosting Profits

Karen Dórame

Learn how to reduce overhead, improve marketing, and increase your studio's overall profitability. *$34.95 list, 8.5x11, 128p, 200 color images, index, order no. 1887.*

On-Camera Flash
TECHNIQUES FOR DIGITAL WEDDING AND PORTRAIT PHOTOGRAPHY

Neil van Niekerk

Use on-camera flash to create lighting that flatters your subjects—and doesn't slow you down on location shoots. *$34.95 list, 8.5x11, 128p, 190 color images, index, order no. 1888.*

Lighting Techniques
for Photographing Model Portfolios

Billy Pegram

Pegram provides start-to-finish analysis of real-life sessions, showing you how to make the right decisions each step of the way. *$34.95 list, 8.5x11, 128p, 150 color images, index, order no. 1889.*

Commercial Photography Handbook

BUSINESS TECHNIQUES FOR PROFESSIONAL DIGITAL PHOTOGRAPHERS

Kirk Tuck

Learn how to identify, market to, and satisfy your target markets—and make important financial decisions to maximize profits. *$34.95 list, 8.5x11, 128p, 110 color images, index, order no. 1890.*

Creative Wedding Album Design

WITH ADOBE® PHOTOSHOP®

Mark Chen

Master the skills you need to design wedding albums that will elevate your studio above the competition. *$34.95 list, 8.5x11, 128p, 225 color images, index, order no. 1891.*

The Beginner's Guide to
Photographing Nudes

Peter Bilous

Covers every aspect of finding models, planning and executing a successful session, and getting your images out into the world. *$34.95 list, 8.5x11, 128p, 200 color/b&w images, index, order no. 1893.*

Portrait Lighting for Digital
Photographers

Stephen Dantzig

Dantzig shows you the hows and whys of portrait lighting and provides demonstrations to make learning easy. Advanced techniques allow you to enhance your work. *$34.95 list, 8.5x11, 128p, 230 color images, index, order no. 1894.*

Freelance Photographer's Handbook, 2nd Ed.

Cliff and Nancy Hollenbeck

From to starting a small business, to delivering images, you'll learn what you need to know to succeed. *$34.95 list, 8.5x11, 128p, 100 color images, index, order no. 1895.*

JEFF SMITH'S

Senior Portrait Photography
Handbook

Improve your images and profitability through better design, market analysis, and business practices. *$34.95 list, 8.5x11, 128p, 170 color images, index, order no. 1896.*

Sculpting with Light

Allison Earnest

Learn how to design the lighting effect that will best flatter your subject. Studio and location lighting setups are covered in detail with an assortment of helpful variations provided for each shot. *$34.95 list, 8.5x11, 128p, 175 color images, diagrams, index, order no. 1867.*

Step-by-Step Wedding Photography

Damon Tucci

Deliver the images that your clients demand with the tips in this essential book. Tucci shows you how to become more creative, more efficient, and more successful. *$34.95 list, 8.5x11, 128p, 175 color images, index, order no. 1868.*

ROLANDO GOMEZ'S

Posing Techniques for Glamour
Photography

Learn everything you need to pose a subject—from head to toe. Gomez covers each area of the body in detail, showing you how to address common problems and create a flattering look. *$34.95 list, 8.5x11, 128p, 110 color images, index, order no. 1869.*

JERRY D'S

Extreme Makeover Techniques

FOR DIGITAL GLAMOUR PHOTOGRAPHY

Bill Hurter

Learn the secrets of creating glamour images that bring out the very best in every woman. *$34.95 list, 8.5x11, 128p, 270 color images, index, order no. 1897.*

Professional Commercial Photography

Lou Jacobs Jr.

Insights from ten top commercial photographers make reading this book like taking ten master classes—without having to leave the comfort of your living room! *$34.95 list, 8.5x11, 128p, 160 color images, index, order no. 2006.*

500 Poses for Photographing Brides

Michelle Perkins

Filled with images by some of the world's best wedding photographers, this book can provide the inspiration you need to spice up your posing or refine your techniques. *$34.95 list, 8.5x11, 128p, 500 color images, index, order no. 1909.*

The Best of Wedding Photojournalism, 2nd Ed.

Bill Hurter

From the pre-wedding preparations to the ceremony and reception, you'll see how professionals identify fleeting moments and capture them in an instant. *$34.95 list, 8.5x11, 128p, 150 color images, index, order no. 1910.*

Softbox Lighting Techniques
FOR PROFESSIONAL PHOTOGRAPHERS

Stephen A. Dantzig

Learn to use one of photography's most popular lighting devices to produce soft and flawless effects for portraits, product shots, and more. *$34.95 list, 8.5x11, 128p, 260 color images, index, order no. 1839.*

THE BEGINNER'S GUIDE TO
Underwater Digital Photography

Larry Gates

Written for the "regular guy" photographer, this book shows you how to make smart technical and creative decisions. *$34.95 list, 8.5x11, 128p, 160 color images, index, order no. 1911.*

Wedding Photography
ADVANCED TECHNIQUES FOR WEDDING PHOTOGRAPHERS

Bill Hurter

The advanced techniques and award-winning images in this book will show you how to achieve photographic genius that will help you win clients for life. *$34.95 list, 8.5x11, 128p, 150 color images, index, order no. 1912.*

Off-Camera Flash
CREATIVE TECHNIQUES FOR DIGITAL PHOTOGRAPHY

Rod and Robin Deutschmann

Break free from the shackles of natural light and push the limits of design with these off-camera flash techniques. Covers portraits, nature photography, and more. *$34.95 list, 8.5x11, 128p, 269 color images, 41 diagrams, index, order no. 1913.*

The Art of Posing
TECHNIQUES FOR DIGITAL PORTRAIT PHOTOGRAPHERS

Lou Jacobs Jr.

Create compelling poses for individuals, couples, and families. Jacobs culls strategies and insights from ten photographers whose styles range from traditional to modern. *$34.95 list, 8.5x11, 128p, 180 color images, index, order no. 2007.*

Photographic Lighting Equipment

Kirk Tuck

Learn to navigate through the sea of available lights, modifiers, and accessories and build the best arsenal for your specific needs. *$34.95 list, 8.5x11, 128p, 350 color images, 20 diagrams, index, order no. 1914.*

Advanced Wedding Photojournalism

Tracy Dorr

Tracy Dorr charts a path to a new creative mindset, showing you how to get better tuned in to a wedding's events and participants so you're poised to capture outstanding, emotional images. *$34.95 list, 8.5x11, 128p, 200 color images, index, order no. 1915.*

Corrective Lighting, Posing & Retouching
FOR DIGITAL PORTRAIT PHOTOGRAPHERS, 3RD ED.

Jeff Smith

Address your subject's perceived physical flaws in the camera room and in postproduction to boost client confidence and sales. *$34.95 list, 8.5x11, 128p, 180 color images, index, order no. 1916.*

Children's Portrait Photography Handbook, 2nd Ed.

Bill Hurter

Excel at the art of photographing children. Includes unique portrait concepts, strategies for eliciting expressions, gaining cooperation on the set, and more. *$34.95 list, 8.5x11, 128p, 150 color images, index, order no. 1917.*

ROLANDO GOMEZ'S
Lighting for Glamour Photography

In this book, renowned glamour guru Rolando Gomez teaches the simple and complex lighting strategies you need to create the figure-enhancing shots that will make every woman look her very best. *$34.95 list, 8.5x11, 128p, 150 color images, index, order no. 1918.*

TUCCI AND USMANI'S
The Business of Photography

Damon Tucci and Rosena Usmani

Take your business from flat to fantastic using the foundational business and marketing strategies detailed in this book. *$34.95 list, 8.5x11, 128p, 180 color images, index, order no. 1919.*

THE DIGITAL PHOTOGRAPHER'S GUIDE TO
Light Modifiers
SCULPTING WITH LIGHT™

Allison Earnest

Choose and use an array of light modifiers to enhance your studio and location images. *$34.95 list, 8.5x11, 128p, 190 color images, 30 diagrams, index, order no. 1921.*

JOE FARACE'S
Glamour Photography

Farace shows you budget-friendly options for connecting with models, building portfolios, selecting locations and backdrops, and more. *$34.95 list, 8.5x11, 128p, 180 color images, 20 diagrams, index, order no. 1922.*

Multiple Flash Photography

Rod and Robin Deutschmann

Use two, three, and four off-camera flash units and modifiers to create photos that break creative boundaries. *$34.95 list, 8.5x11, 128p, 180 color images, 30 diagrams, index, order no. 1923.*